Garden Party

Appliqué Quilts That Bloom

CYNTHIA TOMASZEWSKI

Martingale™
& COMPANY

Credits

President • *Nancy J. Martin*
CEO • *Daniel J. Martin*
Publisher • *Jane Hamada*
Editorial Director • *Mary V. Green*
Managing Editor • *Tina Cook*
Technical Editor • *Ellen Pahl*
Copy Editor • *Melissa Bryan*
Design Director • *Stan Green*
Illustrator • *Laurel Strand*
Cover Designer • *Regina Girard*
Text Designer • *Trina Stahl*
Photographer • *Brent Kane*

Martingale™ & COMPANY

That Patchwork Place®

That Patchwork Place® is an imprint of Martingale & Company™.

Garden Party: Appliqué Quilts That Bloom
© 2003 by Cynthia Tomaszewski

Martingale & Company
20205 144th Avenue NE
Woodinville, WA 98072-8478 USA
www.martingale-pub.com

Printed in China
08 07 06 05 04 03 8 7 6 5 4 3 2 1

Mission Statement

Dedicated to providing quality products and service to inspire creativity.

Library of Congress Cataloging-in-Publication Data

Tomaszewski, Cynthia.
 Garden party : appliqué quilts that bloom / Cynthia Tomaszewski.
 p. cm.
 ISBN 1-56477-447-3
 1. Appliqué—Patterns. 2. Quilts. 3. Flowers in art. I. Title.
 TT779 .T64 2003
 746.46'041—dc21
 2002152792

Dedication

To the wonderful man in my life, my husband, Mike. He shows me the other adventures in life besides quilting, reminds me that on the flip side of every problem is an opportunity, and manages not to react when my excess-luggage bills are totaled. Thank you for your support and encouragement. You truly are the wind beneath my wings. I love you.

Acknowledgments

Very special thanks to:

Donna Ward of Hamilton, New Zealand. Donna machine quilted all of the designs in this book, except Love Notes. Her extraordinary creative talent and expertise always enhance the designs and make them more wonderful in reality than they are in my dreams.

The delightful staff of Martingale & Company. I would like to thank them for inviting me to share my love of quilting and gardens; they have been a joy to work with.

I would also like to thank:

Betty Alderman, my mentor. She always laughs when I say that. She was there for me when Simple Pleasures was just the seed of a dream. Thank you for your encouragement and for generously answering all my questions—I've had a lot!

Rogene Freed, my mom. She taught me how to sew and always told me that with a piece of fabric, skill, and knowledge, there are wonderful things you can do.

Kris Olsen, my forever friend. I can't imagine life without her!

Laurene Sinema, a great role model. She is always positive, with a can-do attitude.

Linda Meserve and Natima Palaskas, the other two of the "three musketeers." I want to thank them for generous encouragement and friendship, from the beginning and always.

Shirley Schubert, the best mother-in-law ever! She did a terrific job of taking care of Simple Pleasures on the other side of the world.

Tehruna Patel, my sounding board and a very dear and special friend.

Zachary Tomaszewski, my son and Webmaster. He keeps my traditional art current with the new millennium and teaches me how to cope with modern technology.

And to all the other family and friends who have been there for me, touching my life in ways they can never know. Thank you to all!

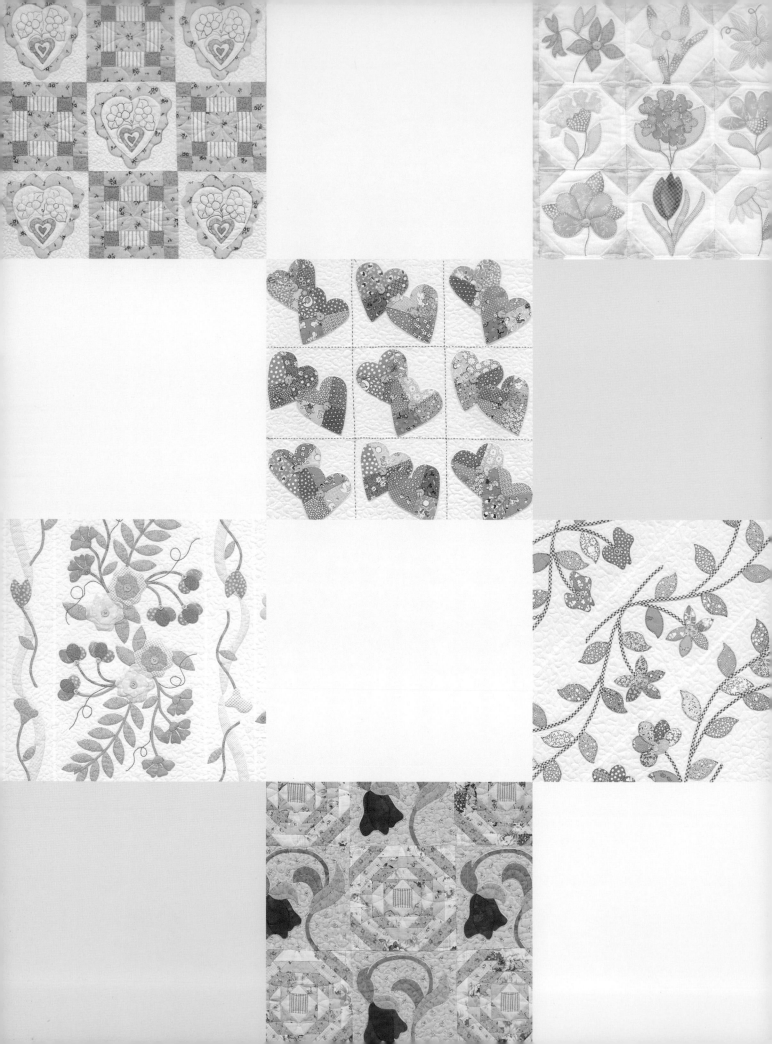

Contents

Preface

I F YOU ARE reading this book, we are already friends, already soul mates. Deep within each of us is a love of quilting that transcends time, distance, cultures, and borders. We speak a special language. We share the desire to create, to unite the world in friendship while sharing a tradition, an art, and a heritage that will survive to inspire others.

I grew up one of six children, firmly rooted in a small town in Michigan. Being the eldest girl, I was my mother's helper. She taught me to sew, and it is from her that I developed my nesting instinct, my passion for collecting, my love of home. But a gypsy heart beats strong and true. I wanted to travel, to have adventures, to see what was out there. I wanted it all!

From the early years of our marriage when we backpacked across Europe, my husband, Mike, and I have continued to travel. Through his work as an engineer, working abroad for an American company, and through our other travel, we have been fortunate to experience different cultures and other ways of life. I am living my dream! Our home always moves with us, and that includes my fabric stash and all my quilting needs.

Quilting is the constant in my life. It's the thread that connects me to friends around the world. Though we speak many languages, participate in different customs and religions, we share our ideas, we inspire, and we teach each other. Above all, we respect our similarities, and more importantly, the differences that make each of us special and unique.

Along with you, I am proud to say I'm a quilter. In these troubled and uncertain times, we must celebrate our participation in an art form that transcends borders. Quilting is not just about fabric and patterns. It is about learning and growing. It's about friendship, sharing, and understanding. Isn't quilting wonderful?

Introduction

R ECENTLY, A WOMAN who was looking at my quilts said to me, "You must like flowers." I thought for a moment. I don't *like* flowers—I *love* flowers! I am passionate about flowers! Why is that? I wondered. Maybe it's because I can't seem to get enough of them in my life. Maybe two years of shipboard living made me appreciate the wonders of a garden.

Like many of you, I am limited by space. We live in a high-rise apartment and I have only a small balcony on which to plant my garden. Also, our weather makes it difficult. Abu Dhabi, United Arab Emirates, where I live, is an island, but it has a desert climate. My flowers struggle to bloom.

In my sewing studio though, flowers are coming up everywhere. They are riotous! There's no stopping them. They bloom. They dance. They are every color under the sun. And the sun's always shining. It's my favorite place to be.

Flowers speak to us and for us. We send them when we're happy. We send them when we're sad. We send them when we care. We show our love with flowers. They speak to us on a cold winter's day, assuring us that spring will one day come. Watching them dance in the sun on a perfect summer's day makes us happy to be alive. They are nature's special gift to us. The designs in this book are my gift to you. They are from my garden with love.

As you page through the book and choose designs to make, add your own color ideas and embellishments. Make the quilts speak for you. Make them special! Share them with your family, friends, and loved ones; they will be from *your* garden with love.

Fabric Selection and Preparation

I HAVE COME TO the conclusion that fabric collecting can be an addiction, or to put it in a more positive light, I should say a *passion*. You can never have too much. It looks good and feels even better. It comes in the most wonderful array of colors, patterns, and textures. If you're like me, you've never met a piece you didn't like, because you know that someday it may be just the perfect fabric you need for that special quilt.

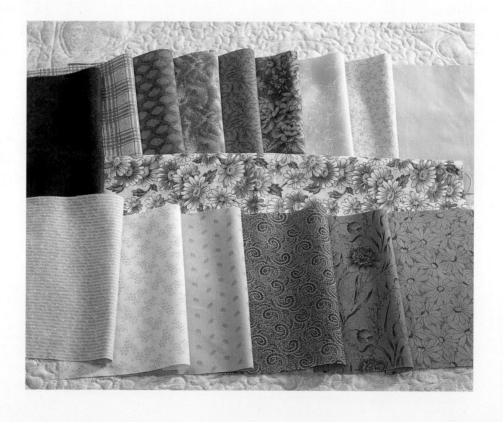

When choosing fabrics for a project, quilters with a large fabric stash may want to search there first. If you are a beginning quilter or fairly new to quilting, I recommend that you visit your local quilt shop for fabrics. The staff there can offer assistance and answer any questions you may have. Fabrics in quilt shops are usually arranged by color groupings, and this will help make the selection process easier. When making your choices, please keep in mind the following recommendations for the best results:

* Purchase good-quality, 100%-cotton fabric.
* Purchase a little extra fabric if possible.
* Choose a wide variety of fabrics.
* Prewash and dry your fabrics.
* Press your fabrics before cutting.

I always stress to my students that they should purchase good-quality, 100%-cotton fabric. You are investing your time and energy in a project or quilt that you want to last. Quality cottons are easy to work with and will stand the test of time.

All of the yardage requirements in this book are based on 42"-wide fabrics with 40" of usable width after washing and removing selvages. Purchasing the suggested amounts will be sufficient for your project, but it is always better to have a little extra than not enough. Accidents can happen in the cutting process, and there is no greater frustration than not having enough fabric to complete your project, with no opportunity to purchase more of the same fabric.

When choosing fabrics, vary the size and type of print, and include some solids as well as geometric designs. Variety is the spice of life and of quilts. A variety of fabrics will make your quilt interesting. Don't feel that the fabrics have to match. Feel free to use different tones of a color as well as contrasting colors. Sometimes the best way to start your selection process is to choose one fabric you absolutely love and must have. Then find other fabrics that will work with your favorite piece.

I recommend that you prewash and dry your fabrics before you start a project. Wash light and dark fabrics separately. If a fabric is going to bleed or run, it's better to know before it can damage your completed project. If by chance you purchase a fabric that bleeds when you prewash it, continue to wash the fabric until your wash and rinse water is clear. Vinegar added to the rinse cycle may help to stop the bleeding. Commercial dye-trapping sheets may also be used in the wash water. These capture any dye that may bleed into the water. If you still have a doubt about the fabric after repeated washing, discard it and choose a different fabric.

Press all fabrics. This will help you measure and cut your fabrics as accurately as possible.

Choosing fabrics for a project is fun and exciting. Be a little daring. Be willing to experiment with different colors and designs, and you'll be amazed at the results.

Basic Tools and Supplies

TODAY'S QUILTERS HAVE the opportunity to choose from an amazing array of tools and gadgets that help with the quilting process. If you're just starting out or if you just like to keep life simple, you need only a few, good-quality tools to produce a beautiful quilt. Consider them an investment.

Thread

Purchase good-quality, strong cotton or cotton-covered polyester thread for piecing and basting your quilt. These are usually 50-weight threads and are available in a wide array of colors. Choose a thread color that matches the predominant color in your quilt, or choose a neutral tone that blends with all the colors.

For hand appliqué, you can use the same thread you'd use for piecing. You might also like to try a lighter 60-weight cotton thread or a 100%-silk thread. These threads are easier to thread through the small eye of the thin needles (Sharps) used for appliqué. Choose a thread color that most closely matches the color of the appliqué piece you will stitch to the background fabric. A neutral-color silk thread blends with almost any fabric color.

Quilting thread is a strong thread, heavier than ordinary thread, that should be used only for quilting. It is too heavy and bulky to be used for piecing or appliqué. Quilting thread comes in a variety of colors.

Needles

Needles come in numbered sizes: the larger the number, the smaller the needle. A good-quality, fine needle will glide through your fabric and make stitching a pleasure.

Betweens are shorter, thicker needles that are used for quilting. They range in size from 8 to 12. Beginners usually start out with larger-size needles (such as a size 8) and gradually work toward smaller sizes.

FRIENDLY ADVICE

If you experience difficulty threading small needles, use a needle threader. Very fine needle threaders that work well with the needles quilters use are now available.

Sharps are longer, thinner needles with a small eye, used for appliqué. Long needles with a large eye are called *crewels*. These may be used with heavier-weight threads for embellishing your quilt.

Quilting needle (Between)	
Sharp	
Crewel	

For machine piecing or machine quilting, purchase machine needles in size 70/10, 80/12, and 90/14.

FRIENDLY ADVICE

Keep your needles in a piece of wool cloth or a wool pincushion. The natural oil in the wool keeps the needles from rusting and helps to keep the tips sharp.

Thimbles

If you are planning to hand piece, hand appliqué, or hand quilt, you will want to wear a thimble to protect your fingertip. Thimbles come in a variety of shapes and sizes. Try several types to see which one works best for you.

Pins

Sharp silk pins with plastic heads are excellent for pinning patchwork pieces together. Extralong "quilter's pins" with plastic heads are useful for pinning the layers of your quilt when it is to be basted and hand quilted. For machine quilting, you will need rustproof safety pins for pin basting the quilt layers together. Small ¾" sequin pins are excellent for pinning appliqué pieces to the background fabric. Because of the pins' short length, thread is less likely to get caught on them.

Scissors

Have one pair of sharp, good-quality scissors to use for cutting fabric only. Use paper scissors to cut plastic or paper templates for piecing or appliqué. Small, very sharp, 4" scissors are excellent for clipping threads or trimming appliqué pieces.

Marking Pencils

Use a sharp, No. 2 pencil or a fine-lead 0.5 mechanical pencil to trace around templates and to lightly mark the quilting lines on the quilt top. If you choose other marking tools, be sure to test them for easy removal from your fabric.

Measuring Tools

Clear, acrylic rulers with both vertical and horizontal measuring lines are ideal for measuring, rotary cutting, and marking straight lines on fabric. Some useful sizes to have on hand are: 1" x 12", 4" x 4", 6" x 6", 6" x 12", 6" x 24", and 15" x 15". An extra-long, 120" tape measure is great for measuring your quilt top when adding borders.

Rotary-Cutting Equipment

There are many different brands and sizes of rotary cutters available. Most quilters use the 1¾" rotary cutters. Select the one you are most comfortable using. Be sure to purchase a replacement blade when you purchase your rotary cutter, and always keep a spare.

To use a rotary cutter, you will also need a self-healing cutting mat. These come in a variety of sizes. The 18" x 24" size is the most useful for cutting strips from fabric.

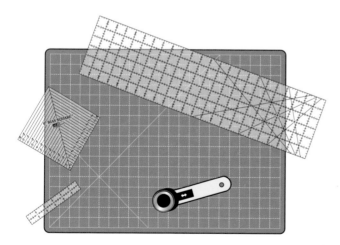

Light Box

A light box is not an absolute requirement for appliqué, but you will find the appliqué process much easier and more enjoyable with this item. Because I do a lot of appliqué, it is one of the most valuable investments I have made in quilting tools. A light box usually consists of a wooden box with a plastic top, and inside the box is an electric light. They come in a variety of sizes. Tracing patterns to make templates is very easy with a light box. You can also use it to trace quilting designs onto your quilt top. If you don't have a light box, you can use a glass-top table with a light underneath or you can tape your pattern to a window for tracing.

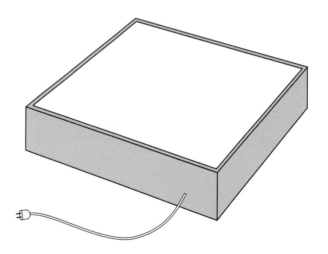

Appliqué

I HAVE HEARD SO many quilters say they don't do the "A word." To be perfectly honest with you, I felt the same way when I first started quilting. There is an aura about appliqué that seems to intimidate the new quilter. It's something we feel that we can't try until we are more advanced—something we shouldn't try until we've proved ourselves. Those thoughts bring to mind Robert Fulghum's book *All I Really Need to Know I Learned in Kindergarten*. If you can trace a drawing and use a pair of scissors—skills you learned in kindergarten—you already have the basic skills to do appliqué. It's that easy.

WHY APPLIQUÉ?

Appliqué is a creative new adventure. It lets you express yourself in a way that pieced quilts alone can never do. Appliqué opens whole new worlds, whole new vistas. It gives you the freedom to create, to experiment, and to personalize your quilt. It gets you out of the box. It helps you deal with all the things in life that are not square. It lets you do things your way. The method or technique is up to you. You can create beautiful, stunning quilts using your preferred method, from the simplest to the most advanced.

The goal of this book is to familiarize you with several methods of appliqué: fusible, freezer-paper, and needle-turn. With each method, I'll share my tips to make it easy, fast, and fun. Once you understand the basics of

each technique, choose the method you think will work best for you. Or choose a combination of two or three in your project to experiment with each. There are no rules, only guidelines and suggestions.

In all of the appliqué designs, you are creating a picture. Pictures give you the sensation of depth. Therefore, some of your appliqué pieces will overlap others. Follow the patterns for the correct placement order of the appliqué pieces. All of the designs in this book will look delightful in whatever method you choose. Let yourself go. Add some embellishments; personalize your quilt. When you appliqué, your garden will grow!

Fusible Appliqué

Fusible appliqué is extra fast and easy. With this technique, there are no seam allowances to turn under. Instead, a bonding material, called fusible web, is used to adhere the appliqué piece to the background fabric. I like to add a decorative stitch, such as the buttonhole stitch (see "Embellishments" on page 20), to secure the edges of the appliqué with stitching. I use it often when working with 1930s reproduction fabrics to give them that old-fashioned look. I love the texture, color, and added depth that the buttonhole stitch gives to the project. Variegated or hand-dyed threads, metallic threads, and other special threads are perfect for fusible appliqué. Combine the stitching with embellishments of beads and buttons for unlimited fun.

Fusible web has smooth paper on one side, with an adhesive on the reverse side. There are many brands on the market, including HeatnBond, Wonder-Under, and Steam-A-Seam. If you want to hand buttonhole stitch your appliqué pieces, purchase the lightest-weight fusible web possible. This is especially important if you are hand stitching through multiple layers of fused fabrics. The adhesive stiffens the fabrics, but with the lightweight fusible web, your quilt will still be soft and pliable.

Be sure to follow the manufacturer's specific directions for the fusible product you choose.

With fusible appliqué, you will draw or trace your templates or patterns in reverse. Use a light box, if available, or an alternative arrangement for tracing. Refer to "Light Box" on page 12.

1. Place your pattern right side down on your light box. Place the fusible web on top of your pattern, with the smooth, paper side up.

2. Use a pencil to trace around the appliqué pattern.

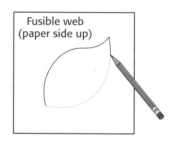

3. Cut the shape from the fusible web, leaving approximately ¼" outside the traced lines.

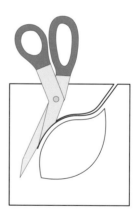

FRIENDLY ADVICE

If your design results in multiple layers of fused fabrics, you can reduce the stiffness of your project by cutting away all but ¼" inside the traced lines. This trimming allows the shape to adhere to the background but eliminates the stiffness of the adhesive within the shape.

4. Place the fusible-web shape on the wrong side of your chosen fabric. Following the manufacturer's instructions, press with an iron. Let cool.

5. Cut out the fabric shape on your drawn lines and remove the paper backing.

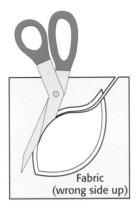

Fabric
(wrong side up)

FRIENDLY ADVICE

Before cutting out the fabric shape along the drawn lines, pull up slightly on one corner of your fusible to loosen it. This makes it easier to remove the paper and prevents your fabric from fraying.

6. Using your pattern as a guide, position the appliqué shape adhesive side down on the right side of the background fabric and press.

7. When all the pieces are fused, finish the edges with a decorative stitch, such as the buttonhole stitch, either by hand or by machine. Refer to "Embroidery Stitches" on page 21.

Freezer-Paper Appliqué

Freezer-paper appliqué is simply an updated version of traditional needle-turn appliqué. It gives you the same look, but many quilters find it easier to use freezer paper because it acts as a sewing guide. It also eliminates the drawn lines, which then have to be hidden during the appliqué process, on your fabric appliqué shapes.

Freezer paper is sold in most supermarkets in the same aisle as the plastic bags and storage containers. It is a white, heavy paper, dull on one side and shiny on the reverse. Be sure to purchase paper that is plastic coated. You can reuse your templates several times, if you wish, before discarding them.

In freezer-paper appliqué, you turn under a seam allowance, using the freezer paper as a guide either on the top or underneath the appliqué piece. Try both methods to see which you prefer.

Freezer Paper Underneath

As in fusible appliqué, draw your templates reversed. Use a light box or an alternative arrangement to do this.

1. Place the pattern right side down on a light box. Place the freezer paper shiny side down on top of the pattern and trace around the pattern with a pencil.

2. Cut out the freezer-paper template on the drawn lines.

3. Place the template on the wrong side of your chosen fabric. Press.

4. Trim the fabric around the paper template, leaving a ⅛" to ¼" seam allowance.

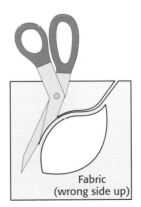

Fabric
(wrong side up)

5. Place your appliqué piece in position, paper side down, using your pattern as a guide. Pin in position, using ¾" sequin pins.

6. Thread a Sharp needle with a colored thread that matches the color of the piece you are appliquéing. Knot the end.

7. Turn under a small section of seam allowance, using the edge of the freezer paper as a folding guide. Start your first stitch by bringing the needle up through the background fabric and through the edge of the folded appliqué fabric. Insert the needle back down through the background fabric and up again about ⅛" away.

8. Continue to take small, even stitches in a counterclockwise direction, turning under the seam allowance as you go and catching just the edge of the fold with each stitch.

Appliqué Stitch

9. When you are about ½" from where you started stitching, fold under the remaining seam allowance and finger-press. Using tweezers, loosen the enclosed freezer paper and remove it through the unstitched opening.

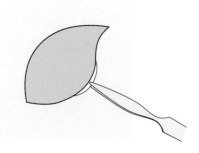

10. Refold the seam allowance and continue stitching a couple stitches past where you began. Make a knot on the wrong side of the background fabric.

Freezer Paper on Top

1. Place your pattern, right side up, on the light box. Place the freezer paper, shiny side down, on top of the pattern and trace around the appliqué design with a pencil. Cut out the freezer-paper template on the drawn lines.

2. Place the template on the right side of your chosen fabric. Press.

3. Cut around the paper template, leaving approximately a ⅛" to ¼" seam allowance.

Fabric
(right side up)

4. Place your appliqué piece in position, paper side up, using your pattern as a guide. Pin in position, using ¾" sequin pins.

5. Stitch as for the "Freezer Paper Underneath" method, following steps 6–8 at left. Use the edge of the freezer paper as your guide for turning under the seam allowance.

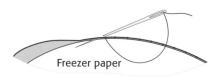

Freezer paper

6. Continue stitching a couple stitches past where you began. Knot the thread on the wrong side of the background fabric. Remove the freezer paper.

TIPS FOR PERFECT HAND APPLIQUÉ

- When you turn under the seam allowance, use the tip of your needle. You may also use what I call the "toothpick method"; I learned it from quilt designer and teacher Laurene Sinema. Use a Chinese toothpick (pointed on only one end) or a regular round toothpick. Moisten it slightly and use the point to roll, turn, and smooth the seam allowance ahead of you as you sew.

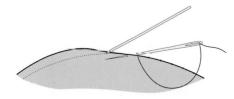

- Do not sew edges that will be covered by other motifs.

- If you are working with fabric that frays easily, leave a larger than normal seam allowance and trim to the required ⅛" to ¼" as you stitch the appliqué piece in position.

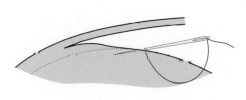

- When appliquéing both inner and outer curves, clip the seam allowance at regular intervals to allow the seam allowance to expand and curve.

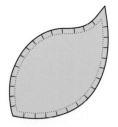

- When appliquéing an inner point, clip at the point. Stitch to the clip, take one or two stitches right at the clip, and then turn and continue to sew.

- When appliquéing points, take two stitches at the point. Flip the point fabric back and trim away excess fabric from underneath before turning and continuing to sew down the next side. This should give you a sharp, flat point.

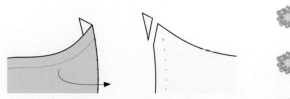

Flip back and trim excess fabric.

Needle-Turn Appliqué

Traditional needle-turn appliqué has been with us since the beginning of quilting. It requires no special tools or supplies. It is a technique that is especially useful on very small or intricate appliqué pieces. The only thing you have to remember is to be sure to turn under enough seam allowance to cover your drawn lines.

1. Place your pattern right side up on a light box. Make a template of the appliqué design. Cut out the templates on the drawn line.

FRIENDLY ADVICE

Template material may be plastic, cardboard, or even freezer paper. If you are reusing the templates several times, make them from template plastic so the pieces retain their correct size and shape.

2. Place the template on the right side of the chosen appliqué fabric and trace around it with a No. 2 pencil.

3. Cut out the fabric shape, leaving a ⅛" to ¼" seam allowance.

4. Place your appliqué piece in position, right side up, using your pattern as a guide. Pin in position, using ¾" sequin pins.

5. Thread your Sharp needle with a thread that most closely matches the color of the piece you are appliquéing. Knot the end.

6. Turn under a small section of seam allowance and finger-press. Start your first stitch by bringing the needle up through the background fabric and through the edge of the folded fabric. Insert the needle back down through the background fabric and up again about ⅛" away.

7. Continue to take small, even stitches in a counterclockwise direction, turning under the seam allowance with the tip of the needle as you go and catching just the edge of the fold with each stitch. *Be sure to turn under enough seam allowance to cover your drawn lines.*

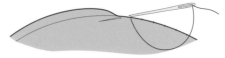

8. Continue stitching a couple stitches past where you began. Knot the thread on the wrong side of the background fabric.

POSITIONING YOUR APPLIQUÉ DESIGNS

For some of the appliqué designs, you will want to make a tracing of the pattern to help you position the appliqué shapes on the background. Trace the pattern, including all the pieces, onto a piece of paper. Use the crosshatch mark in the pattern or the seam lines to center the design on the background fabric. Mark the center of the background fabric by folding it in half and then in half again. Finger-press to mark the middle of the block.

Place your pattern right side up on a light box. Place your background fabric right side up on top of your pattern. Line up the middle of the background with the crosshatch of the design, or center the background fabric on the seam lines. Position and pin the appliqué pieces, using your pattern as a guide. For layered shapes, you may need to appliqué the first pieces, and then go back to the light box and position the next shapes to be appliquéd. You may also want to mark any lines for embroidery stitches at this time. Mark them lightly with a No. 2 pencil.

Making Bias Vines

Bias strips are used for making flower stems and wandering vines. Using a bias-tape maker is the fastest and easiest method I have found to make bias stems. They come in a variety of sizes from ¼" to 2". To make a ⅛" to ¼" bias stem, cut a ½" bias strip that is at a 45° angle to the selvage of your fabric. Use your longest rotary ruler and line up the 45° angle with the selvage edge.

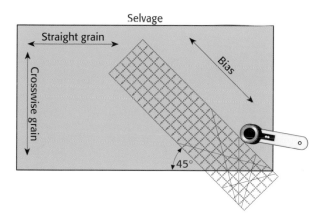

You may need to piece the strips together to obtain the length needed. To do this, place the strips right sides together, offsetting them by ¼". Stitch together using a ¼" seam allowance. Press the seams open to mimimize bulk.

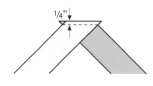

1. Place one end of the bias strip into a ¼" bias-tape maker. Pull just the tip of the strip through the bias tape maker and pin it to your ironing board.

2. Continue to pull the bias-tape maker slowly along the strip, following close behind the bias-tape maker with your iron to crease the edges of the fabric as it emerges from the bias-tape maker.

3. Pin in position with ¾" sequin pins; appliqué with matching thread.

POSITIONING PERFECT VINES

The delightful appeal of the wandering vines in many of the quilt borders is due to the fact that they are not perfectly symmetrical. Use the photos and the border layouts as guides to determine the flow of your border, but if it differs slightly, don't worry. Vines wander in nature, and no two are *exactly* the same—that's their charm!

Embellishments

Y USE OF embellishments on quilts started out quite innocently. Early on in my quilting days, I experienced the nightmare of every quilter: I cut a hole in my quilt in the final stages of quilting! PANIC!!! How could I fix that hole? I decided to cover it with a button—a very special button. That button looked so wonderful, I put on a few more. One thing led to another, and the rest, as they say, is history. Today, there are not many quilts that leave my studio without some type of embellishment.

Quilts and embellishments go together like peanut butter and jelly.

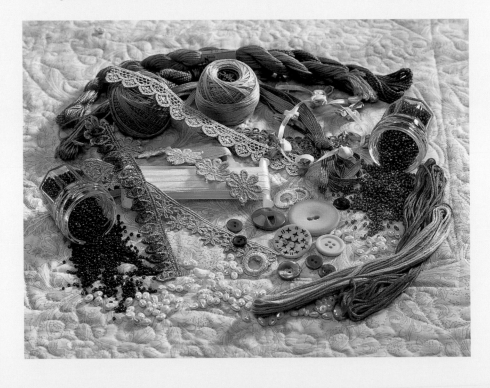

And what wonderful things to collect! Buttons, beads, and threads all come in the most luscious colors and textures. They look wonderful in old jars on your studio shelves. Old collections are so much fun to sift through, letting you imagine and wonder where the items have been and what stories they might tell. Many of the quilts in this book include embellishments, which, of course, are optional. Be adventurous though, and try some simple embellishments.

CAUTION

Please refrain from using buttons or small embellishments on quilts intended for use by infants or toddlers. The small embellishments could be a choking hazard.

Buttons

When adding buttons to your quilt, you may sew them on in the traditional manner. If they are going to be flower centers, you might want to tie them on using six-strand embroidery floss; tie them so that the thread tails are on top of the button.

To tie the button on, push the needle down through the buttonhole, leaving a 2" to 3" tail. Bring the needle back up through the opposite buttonhole and cut the thread 2" to 3" above the button. Tie the thread tails in a square knot to secure the button. Trim the thread so it is ¼" to ½" long.

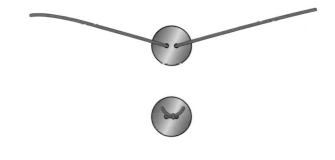

THINGS TO COLLECT

Here are a few of my favorite things to collect for embellishing my quilts:

- Buttons
- Beads
- Pearl cotton thread: sizes 8 and 12
- Cotton embroidery floss: 6-strand regular, variegated, and hand dyed
- Metallic threads
- Silk ribbon: 4mm and 7mm
- Trims, braids, laces, and tassels

Embroidery Stitches

Mark embroidery design lines lightly with a No. 2 pencil, using the traced pattern and a light box or other arrangement (see "Light Box" on page 12). You can mark them when you're positioning appliqué shapes, using the pattern as a guide. I use these stitches most often in embellishing my quilts.

Straight Stitch or Running Stitch: Sew evenly spaced stitches, following your marked line.

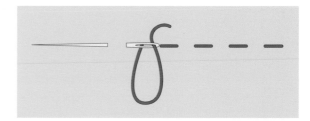

Stem Stitch: Bring the needle up at A and down at B. Repeat, bringing the needle up at C and down at D. Continue, keeping the thread on the same side of the stitching line.

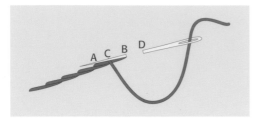

Buttonhole Stitch: Bring the needle up at the edge of the piece, and work from left to right.

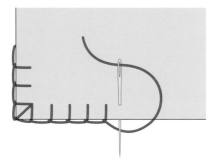

Cretan Stitch: Bring the needle up at A on one side of the seam or patch. Move to the other side and insert the needle at B and come up at C. Repeat by moving to the other side, inserting the needle at B and coming up again at C.

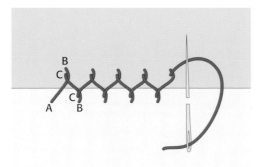

Cross Stitch: Bring the needle up at A and down at B. Continue to make as many diagonals as needed, then reverse direction to cross your stitches.

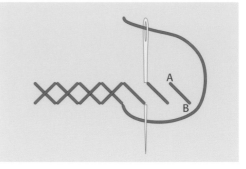

Feather Stitch: Bring the needle up at A and down at B, creating a U. Bring the needle up at C to anchor the U, then insert it down at D, creating a second U. Repeat.

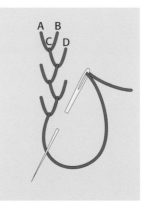

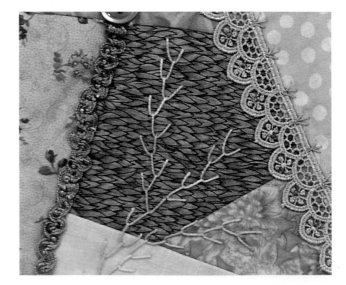

French Knot: Bring the needle up at A. Wrap the thread around the needle three times. Tighten the wrapped thread and hold the tension with your thumb as you insert the needle back down at B, very close to A. Pull tight to create the knot.

Beaded Ribbons: Tie a bow with two or three pieces of silk ribbon. Leave the bow large enough to be able to twist and turn the loops as you sew them in position. Tack the bow to the quilt. Twist and turn the ribbon as you use small beads to sew the loops and tails in place.

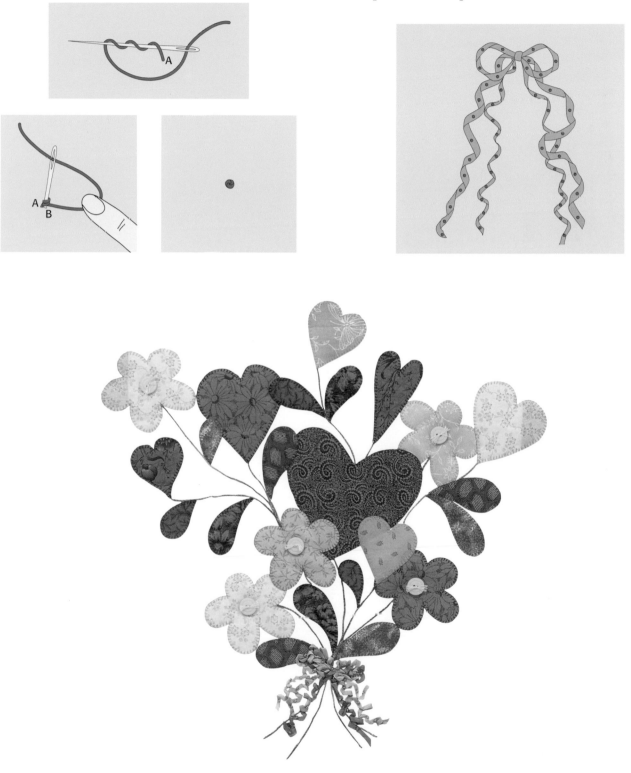

Quiltmaking Basics

*T*HIS SECTION CONTAINS a brief overview of the other quilting techniques you'll need to know to make your quilts, from cutting the patches to binding and adding a label.

Rotary Cutting

Many quilters today use the fast, very accurate rotary-cutting method to cut out their patchwork pieces. Rather than using a plastic or cardboard template to mark and cut each individual patchwork piece, rotary cutters can easily cut through up to eight layers of fabric at a time, producing accurate patchwork shapes without marking. Rotary cutting is usually used in conjunction with machine piecing, since the sewing line is not marked, and the ¼" seam allowance is included in the cutting dimensions.

1. Fold the fabric and match the selvages. Place the folded edge closest to you on the cutting mat. Align a square ruler along the folded edge of the fabric. Place a long ruler to the left of the square ruler, covering the uneven raw edges of the fabric. Remove the square ruler and hold the long ruler firmly with your left hand. Cut along the right edge of the long ruler with a rotary cutter. Now you have a straight edge to cut strips and other shapes.

2. To cut strips, align the newly cut edge of the fabric with the lines on the ruler at the required width. Cut the strip.

3. To cut squares or rectangles, first cut a strip the required width. Trim the ends and align the left edge with the correct ruler lines. Cut the squares or rectangles as needed.

4. To cut a half-square triangle, determine the finished length of the short side of the triangle and add ⅞". Cut a square this measurement and cut across it diagonally once from corner to corner. Each square yields two half-square triangles, with the straight grain of the fabric on the short sides.

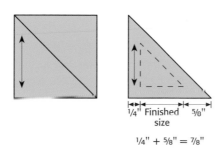

¼" Finished 5/8"
size

¼" + 5/8" = 7/8"

5. To cut a quarter-square triangle, determine the finished length of the long side of the triangle and add 1¼". Cut a square this measurement and cut it twice diagonally. Each square yields four quarter-square triangles with the straight grain on the long side of the triangle.

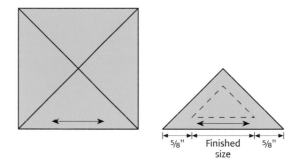

5/8" Finished 5/8"
size

Hand Piecing

I hand piece many of my quilts. A big advantage of hand piecing is that it can be done anytime and anywhere, at home or while you are traveling. Hand piecing is the traditional, peaceful, time-honored method of constructing a quilt. I think of it as a slow, gentle process in a hurry-up world.

For hand piecing, make a template from either lightweight plastic or cardboard in the exact size of the finished patchwork piece. I recommend plastic, because the template does not wear down with continued use.

1. Place the template on the wrong side of your chosen fabric, being aware of the grain lines of the fabric. Trace around the template with a No. 2 pencil. Leave at least ½" between each tracing. The drawn lines are your sewing lines. Cut out each piece with scissors, leaving a ¼" seam allowance around the tracing.

Trace around template.

2. Place two fabric pieces right sides together and pin, matching pencil lines exactly at the corners and along the seam line. Use a regular sewing thread, in a matching color, knotted at the end. Stitch the fabric pieces together, using a small running stitch, backstitching and knotting the thread at the beginning and the end of each seam to secure your stitching. Seam allowances should remain free. Trim seams so they are ⅛" to ¼" wide. Press the seams toward the darker fabric when possible. When sewing patchwork units together, avoid sewing across the seam allowance. On long seams, backstitch at regular intervals to secure your seam.

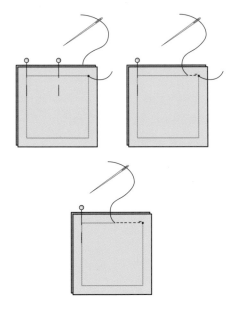

FRIENDLY ADVICE

Hand piecing may also be done with rotary-cut patchwork pieces. Cut out the patchwork pieces, including a ¼" seam allowance. Using a ruler and a No. 2 pencil, draw a line around the piece, ¼" inside the cut edge. The drawn line is your sewing line.

Machine Piecing

Set your machine stitch length at approximately 10 to 12 stitches per inch. Make sure your seam allowance is an accurate ¼" so the patchwork pieces fit together perfectly. Any variation in this measurement will affect the overall size of your quilt. Line up the cut edges of your fabric pieces precisely and stitch. Backstitching is not necessary, since the seams will cross each other.

When joining two sets of patches, plan your pressing so that the seams are pressed in opposite directions. This eliminates bulk and ensures that the seams nestle together when you sew. Press seams toward the darker fabric, when possible, and press as you go.

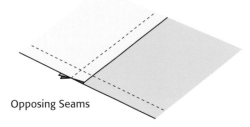

Opposing Seams

Paper Piecing

Paper piecing is a wonderful method to use when working on blocks with many small pieces or lots of points. It is extremely accurate, plus fast and fun!

Make as many photocopies of the paper foundation pattern as you will need. Always make copies from the same photocopier and from the original pattern since distortion may occur between photocopiers and between subsequent generations of patterns. You can also trace the pattern onto foundation papers if you prefer. The marked lines are your sewing lines. All fabric is placed for stitching on the unlined side of the foundation pattern. Fabric pieces are sewn to the foundation paper in numerical order.

1. Cut your fabric into strips, approximately 1" longer and wider than the finished area for which it will be used.

2. Place the first fabric piece on the unlined side of the foundation paper, right side up. Hold the foundation paper up to the light, making sure that the fabric piece adequately covers the area marked *center* and enough fabric surrounds the area for adequate seam allowances.

3. Place the second fabric piece right side down. Make sure that you have adequately covered area 1 before sewing by securing the fabric pieces with straight pins. Remove the straight pins before sewing.

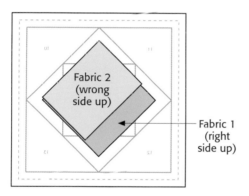

Fabric 2 (wrong side up)

Fabric 1 (right side up)

4. Set your sewing-machine stitch length between 15 and 20 stitches per inch. The stitch length should be small enough so you can easily remove the foundation paper but not so small that it tears the paper as you are sewing.

5. Begin and end the seam line two or three stitches beyond the end of the line. The next seam line will secure the stitches so it is unnecessary to backstitch any of the seam lines.

6. Trim seam allowances so they are ⅛" to ¼" wide, being careful not to cut the foundation paper. Finger-press or use a wooden iron to press the fabric into position. Press again with a dry iron. Always press as you go.

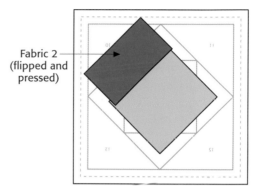

Fabric 2 (flipped and pressed)

PERFECT PRESSING

If you use a wooden iron before pressing with a dry iron, the resulting seam will be pressed fully open and flat. A wooden iron is the secret to great-looking paper piecing. This small tool is available in quilt shops and through mail order catalogs.

7. Continue sewing the pieces to the foundation paper in numerical order until the block is complete.

8. Trim away the excess fabric around the edges of the block, being sure to leave a ¼" seam allowance. Do not remove the foundation paper until the blocks have been set together.

Setting the Blocks Together

Typically, quilt blocks are set together either in a straight line or on the diagonal. With either setting, remember these points:

* Arrange the blocks, following the directions of your chosen pattern.
* Ensure that each block is the same size.
* Sew the blocks of each row together.
* Press the seams of each row in opposite directions.
* Sew the rows together.
* Press as you go.

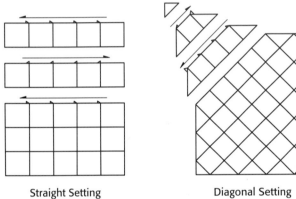

Straight Setting Diagonal Setting

Adding the Borders

After the center blocks are sewn together, add the borders. Since seam allowances can vary and slight stretching can occur on the sides, always measure your quilt through the center to determine the exact length of the borders. This prevents your borders from rippling. In the cutting instructions, I often have you cut the border strips longer than necessary. Then you will cut them to size after the quilt top is assembled.

1. To add the top and bottom borders, measure across the center of your quilt. Trim the top and bottom border strips to this measurement and sew to the top and bottom of your quilt. Press the seams toward the borders.

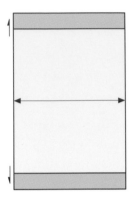

2. To add the side borders, measure lengthwise through the center of your quilt, including the top and bottom borders. Trim the side border strips to this measurement and sew the strips to the sides of your quilt. Press the seams toward the borders.

3. Repeat this same process for each border added.

Quilting and Finishing

 OW THAT THE quilt top is appliquéd and pieced together, you're ready for the next phase: quilting and binding. Decide whether you will quilt by hand or machine, and read on for the final details.

Marking Quilting Designs

It is always preferable to mark your quilt top before layering and basting the quilt. This will give you smooth, accurate, straight lines. There are many different marking tools on the market. Always test any marking tool on your fabric to ensure that the marking lines are easy to remove. My favorite way to mark is to use a sharp No. 2 pencil or a mechanical pencil. Traced very lightly, the lines will remain during constant handling and will be covered by the quilting line. I have found that a pencil works well even on black fabric.

To draw straight lines on your quilt, use an acrylic rotary-cutting ruler with multiple parallel lines to keep your drawn lines straight. For more complex designs, you may wish to purchase precut plastic stencils or templates. They come in a wide array of sizes and designs.

Quilting Stencil

Backing

You may choose a plain or print fabric for your backing fabric. Print fabrics make your quilt back different, exciting, and fun; they also camouflage less-than-perfect quilting stitches.

Cut the backing fabric 5" larger than the quilt top on all sides (10" larger overall). This makes hand quilting the edge of your quilt much less frustrating, because you have enough fabric to fit into a quilting frame or hoop.

It may be necessary to piece the backing of your quilt. If so, center the seam either horizontally or vertically through the center of the quilt. Press the seam open to eliminate bulk.

Batting

The thicker the batting, the more difficult it is to quilt. If you are hand quilting, choose a thin batting that will make it easy to take small, even stitches. Batting comes in many different thicknesses and in cotton, polyester, or wool. Follow the manufacturer's directions for your chosen batting for best results. Try several battings to see which you like best. My personal favorite is a thin, polyester batting. It is lightweight; washes and dries well without shrinking; allows me to produce small, even stitches; and gives a thin, old-fashioned look to the quilt.

Before layering and basting, remove the batting from the package, unfold it, and let it relax overnight. This allows the crease lines to relax and makes it easier to use.

Layering the Quilt

Basting the quilt top, batting, and backing together prevents the layers from shifting during the quilting process. Press both the backing and the quilt top so that they are smooth, wrinkle-free, and easy to handle.

1. Place the backing, right side down, on a large table or the floor. Use 1½"-wide masking tape to fasten the corners and sides of the backing to the table or floor, smoothing away any ripples as you work.

2. Lay the batting on top of the backing. Smooth out any ripples. Trim the batting to the same size as the backing fabric.

3. Lay the quilt top right side up on top of the batting. Use masking tape to fasten the corners and sides of the quilt top in position, smoothing out any ripples as you work.

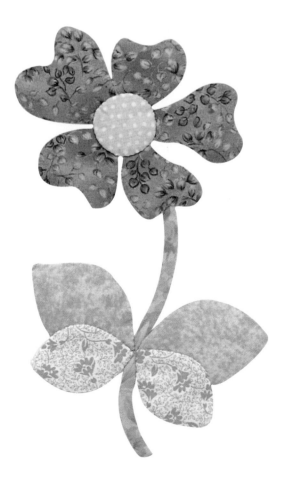

4. Pin all the layers together with long quilter's pins.

5. For hand quilting, baste all three layers together, using a light-colored thread. Dark threads may stain light fabrics if left in for a long period of time. Stitch basting rows both horizontally and vertically approximately 4" to 6" apart. Also place a row of basting around all edges of the quilt. Remove the pins and masking tape.

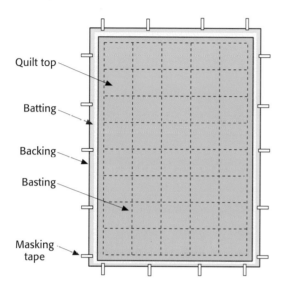

Quilt top

Batting

Backing

Basting

Masking
tape

FRIENDLY ADVICE

Machine Quilters Only

For machine quilting, use safety pins for basting the layers together. Basting stitches can easily get caught on the sewing machine as you're quilting. Place pins about 4" apart.

Quilting

The quilting stitch is a short running stitch used to hold all three layers of the quilt together. Quilting may be done either by hand or by machine. Hand quilting is the time-honored, traditional method of quilting, but it takes much longer than machine quilting. It is really a matter of personal preference and deciding which method will be most suitable for the time you have and the end use of the quilt.

Hand Quilting

For hand quilting, use quilting thread and a short Between needle, size 8, 10, or 12, whichever you find most comfortable to use. Remember: the larger the number, the smaller the needle. Beginners might like to start with a size 8 needle until they become comfortable with the quilting process. In hand quilting, the object is to achieve small, even stitches. With practice, your stitch size and spacing will become consistent, after which you may prefer to use smaller needles.

1. Place the quilt in a hand-held hoop or frame or a floor frame. Make sure that the quilt is not pulled too tightly within the frame because this distorts the shape of the quilt and makes it difficult to achieve the rocking motion that produces small, even stitches.

2. Thread the needle with a length of quilting thread approximately 18" to 20". Knot one end.

3. Approximately 1" from where you want to start quilting, insert the needle between the layers of the quilt and come up at the point where you wish to start. Tug the thread and pop the knot through the fabric so that it is buried between the layers of the quilt.

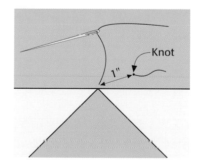

Knot

1"

4. Wear a thimble with a raised edged on your middle finger to help control and push the needle during the rocking, down-up motion of the needle. Place your other hand under the quilt to ensure that the needle is traveling through all three layers of the quilt with each stitch. Use

your thimble to push the needle down through the layers until you feel it with the finger of your underneath hand. Then rock the needle back up through the layers to the top. Repeat to load several stitches on the needle before pulling the thread through.

5. At the end of the quilting line, take a small backstitch. Make a knot close to the surface of the quilt top. Tug and pop the knot so that it is buried between the quilt layers. Clip the thread close to the surface of the quilt top, and the tail will disappear between the layers of the quilt.

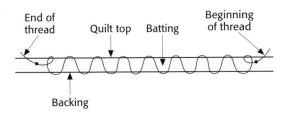

6. When the quilting is complete, remove all basting threads from the quilt.

Machine Quilting

If you are going to machine quilt, you will need a walking foot or dual-feed mechanism for your sewing machine to feed the layers through evenly. For free-motion quilting, you will need a darning foot. Follow the manufacturer's recommendations for your particular sewing machine or equipment and practice until you are comfortable with the technique. There are many good machine-quilting books that can be helpful for beginners.

Binding

Before binding your quilt, trim the excess batting and backing even with the quilt top and square up the corners and sides so that they are as straight and even as possible. Remove all excess threads. You may wish to baste closely along the edges of your quilt to prevent the edges from slipping while you are adding the binding.

Binding is the last step of constructing your quilt and the finishing touch that binds the edges together. You may wish to use a coordinating or contrasting fabric for the binding. To determine the length of binding you will need, measure all four sides of your quilt and add 18". Cut the binding strips 2" wide for a ¼"-wide finished binding.

1. Stitch the ends of the strips together on the diagonal to create one long binding strip the length you will need. Trim the excess fabric, and press the seams open to eliminate bulk. Trim the ends at a 45° angle.

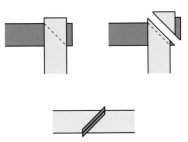

2. Fold the strip in half lengthwise, wrong sides together, and press.

3. Starting in the center on one side of the quilt, place the binding on top of the quilt top, with raw edges together. Start sewing several inches from the end of the binding. Sew through all layers, using a ¼" seam allowance.

4. Stop ¼" from the corner. Cut the threads and remove the quilt from the machine. Fold the binding strip up, creating a 45° angle. Holding the 45° fold in place, bring the binding down so that all raw edges meet. Start sewing from the edge of the quilt, through all layers.

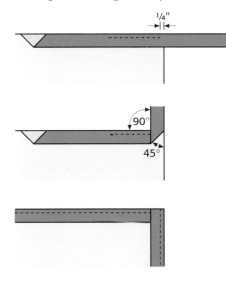

5. Continue around the quilt in the same manner. Stop sewing several inches from where you started and backstitch. Cut the threads. Remove the quilt from the machine. Lap the starting end of the binding over the loose end. Mark a diagonal line even with the edge of the starting binding. Cut the binding end at a 45° angle, ½" longer than your mark.

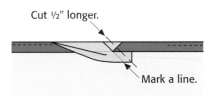

6. Sew the two ends together, right sides together. Press the seam open to eliminate bulk. Refold the binding in half and press. Finish sewing the binding in place.

7. Turn the binding over the edge and hand stitch, using a blind stitch. Make sure to cover any machine stitching. Miter each corner by folding down one side first and then the other.

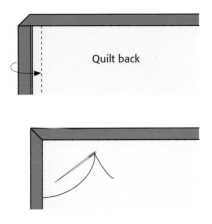

Labels

Labeling your quilt is a wonderful finishing touch and a way to pass important and interesting information on to future generations who will appreciate and treasure your work. While we admire and marvel at the beauty of quilts in historical collections today, we are often curious and wonder who made them, where and when, and what stories these quilts could tell.

Any plain fabric, such as muslin, is a good choice for your label. The size will be determined by how much information you wish to include. You may embroider your label or use a permanent pen or paint to embellish your label. Some information you may want to give on the label is the name of the quilt, your name, including your address, the date, and a dedication or a special story about the quilt.

Sew the label to the back of the quilt as you would an appliqué piece.

Heart Strings

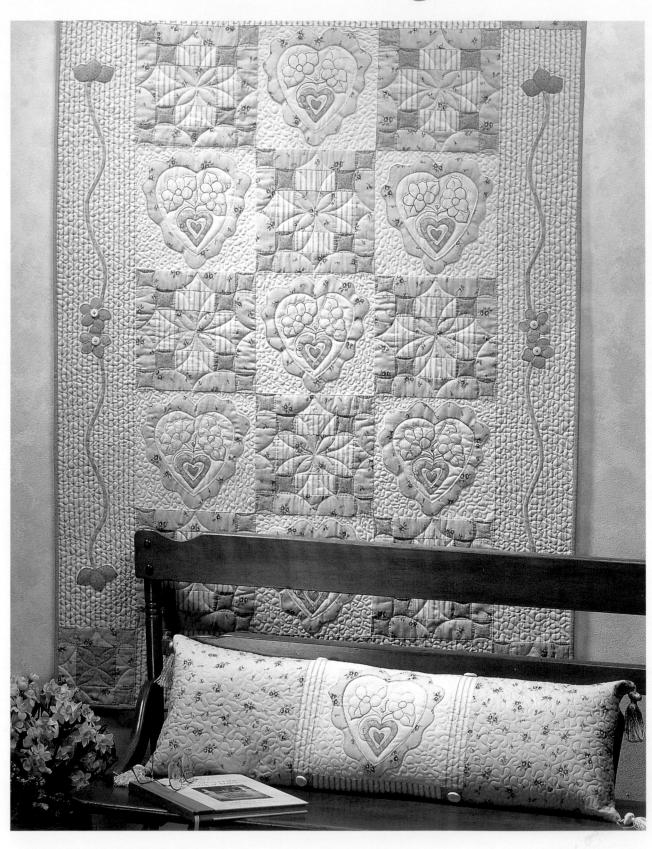

Pull the strings and peek inside,
Where love grows and dreams abide.

Quilt size: 39" x 57" • Pillow size: 12" x 33"

Materials for the Quilt and Pillow

Yardage is based on 42"-wide fabric.

- 2¼ yds. of blue ticking for pieced blocks and border
- 1½ yds. of floral print for pieced blocks and appliqué blocks
- 1 yd. of off-white fabric for background of appliqué blocks
- ½ yd. of green print 1 for hearts and bias stems
- ½ yd. of green print 2 for pieced blocks, leaves, and small hearts
- ½ yd. of blue print 1 for flowers and binding *pink*
- ⅜ yd. of blue print 2 for pieced blocks and flowers

- 2 yds. of fabric for backing
- ¾ yd. of muslin for backing of quilted pillow top
- 49" x 67" piece of batting for quilt
- 22" x 43" piece of batting for pillow
- Green-and-blue variegated 6-strand embroidery floss
- 8 off-white buttons, ⅝" diameter, for flower centers
- 4 off-white buttons, ⅞" diameter, for pillow
- 4 off-white tassels for pillow
- Stuffing for pillow

Cutting for the Quilt

All measurements include ¼" seam allowances.

From the blue ticking, cut:
- 16 rectangles, 2" x 3½", from the crosswise grain
- 16 rectangles, 2" x 3½", from the lengthwise grain

- 2 strips, 6½" x approximately 29", from the crosswise grain
- 2 strips, 6½" x approximately 47", from the lengthwise grain

From the floral print, cut:
- 8 squares, 3½" x 3½"
- 32 rectangles, 2" x 6½"
- 16 rectangles, 2" x 3½"

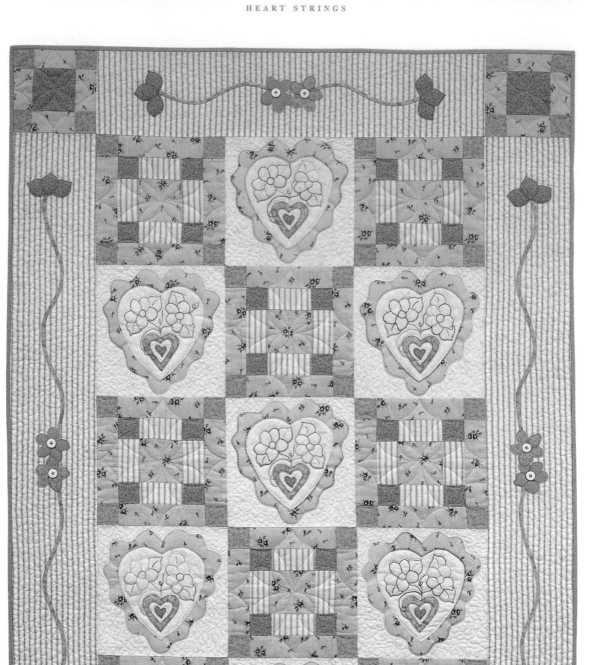

Patchwork, appliqué, and embroidery combine to make this delightful quilt and coordinating pillow.
A buttonhole stitch accents the hearts and emphasizes the old-fashioned charm of striped ticking and buttons.
Make it in soothing blues and greens, or select your own color combination.

From green print 2, cut:
* 4 squares, 3½" x 3½"
* 32 squares, 2" x 2"

From blue print 2, cut:
* 48 squares, 2" x 2"

From the off-white fabric, cut:
* 7 squares, 9½" x 9½"

From green print 1, cut:
* 4 bias strips, ½" x 10"
* 4 bias strips, ½" x 20"

From blue print 1, cut:
* 5 strips, 2" x 42"

Making the Pieced Blocks

1. Sew together four 2" x 3½" ticking rectangles, a floral print square, and four 2" green print 2 squares as shown. Be sure to orient the ticking rectangles so all the stripes run in the same direction. Press.

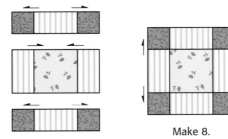

Make 8.

2. Sew four 2" x 6½" floral print rectangles and four 2" blue print squares to the unit from step 1 as shown. Press.

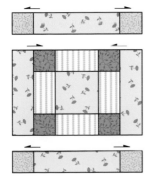

Make 8.

Making the Appliqué Blocks

1. Choose your favorite method of appliqué and make templates for the hearts, flowers, and leaves by tracing the patterns on page 41. Refer to "Appliqué" on page 13 for details as needed. Cut out the number of each shape indicated on the patterns.

2. Appliqué the three hearts cut from templates 1, 2, and 3 to each of the off-white background squares.

3. Trace the embroidery design on page 41 onto the background squares and embroider the flower design, using a stem stitch and two strands of embroidery floss.

Assembling the Quilt Top

1. Sew the pieced and appliquéd blocks together in five rows of three blocks each. Press seams in opposite directions from row to row. Sew the rows together. Press the seams toward the bottom row.

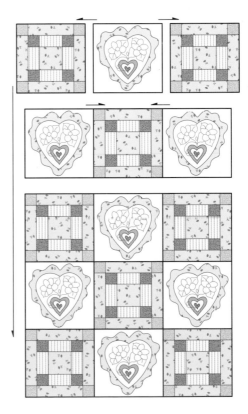

2. Referring to "Making Bias Vines" on page 19, make ¼"-wide bias vines from the green bias strips. Make four vines approximately 20" long for the side borders and four vines approximately 10" long for the top and bottom borders.

3. Using the photo on page 36 as a guide, position the vines on the striped ticking borders and appliqué them in place.

FRIENDLY ADVICE

When positioning vines and other appliqués in a border, fold the border strip in half and lightly crease the center. Use that as a guide to help you center the designs. When it's time to trim the border strip to the measurement of the quilt, fold the border strip along the crease line again and trim it to the dimension needed.

4. Position and appliqué the leaves and flowers on the borders.

5. Make the four corner blocks by sewing together the 3½" square of green print 2, four 2" x 3½" floral rectangles, and four 2" blue print 2 squares.

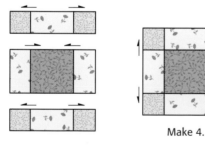

Make 4.

6. Measure across the center of your quilt and trim the top and bottom 6½" x 29" ticking border strips to this measurement. Measure lengthwise through the center of your quilt, and cut the 6½" x 47" side border strips to this measurement. Sew the strips to the top and bottom of the quilt. Press the seams toward the border.

7. Sew the corner blocks to the side border strips. Press the seams toward the border. Sew the side border strips to the quilt. Press.

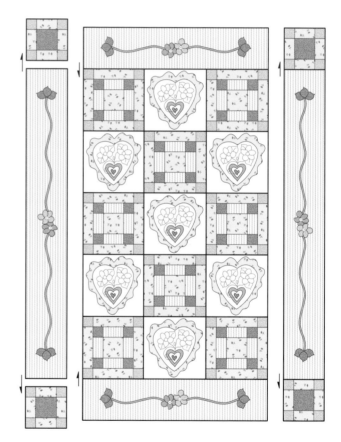

Finishing the Quilt

Refer to "Quilting and Finishing" on page 29 for more details if needed.

1. Mark a quilting design on the quilt top if desired. See the quilting suggestion below.

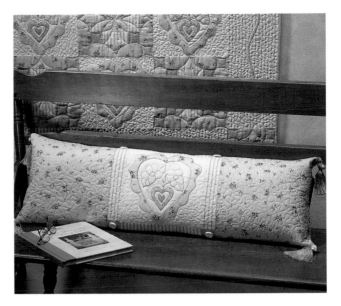

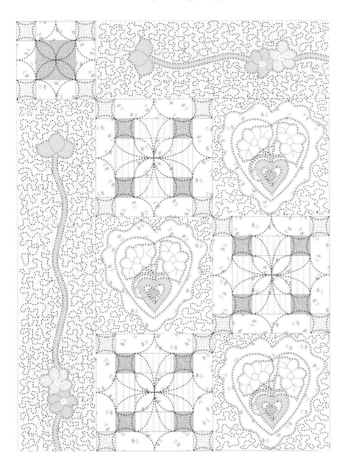

2. Layer the quilt top with batting and backing; baste.

3. Quilt by hand or machine.

4. Bind the edges of the quilt with the blue print 1 strips.

5. Sew the buttons to the flower centers.

6. Add a label to the back of your quilt.

Cutting for the Pillow

All measurements include ¼" seam allowances.

From the off-white, cut:
- 1 square, 9½" x 9½"

From the blue ticking, cut:
- 4 strips, 2" x 9½"
- 2 rectangles, 12½" x 18½"

From blue print 2, cut:
- 4 squares, 2" x 2"

From the floral print, cut:
- 2 rectangles, 11" x 12½"

Assembling the Pillow

1. Cut out three hearts using templates 1, 2, and 3 (patterns on page 41). Appliqué the three hearts to the off-white background square.

2. Trace the embroidery design on page 41 onto the background square and embroider the flower design, using a stem stitch and two strands of embroidery floss. Refer to "Embellishments" on page 20 if needed.

3. Sew ticking strips to the sides of the appliqué square and press. Sew two blue print 2 squares to the ends of the remaining ticking strips. Press the seams toward the ticking fabric. Sew the units to the top and bottom of the appliquéd square. Press.

4. Sew the two floral print rectangles to the sides of the center unit. Press.

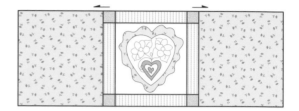

5. Mark quilting designs, if desired, and layer the pillow top with batting and backing cut from the muslin; baste. Quilt on the marked lines.

6. After quilting, trim the excess backing and batting even with the pillow top.

7. Make a ¼" hem on one 12½" end of each of the rectangles of blue ticking.

8. Place the pillow top right side up. Position the tassel ends at each corner and pin so that they will be sewn into the seam allowance.

9. Place the hemmed ticking rectangles, right side down, over the pillow top so the hemmed ends overlap by about 3" and the outer edges are aligned.

Overlap

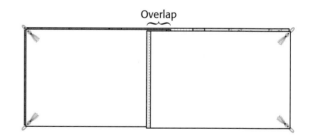

10. Sew around the edge of the pillow, using a ¼" seam allowance.

11. Turn the pillow right side out, and sew buttons to the four blue print squares. Stuff as desired.

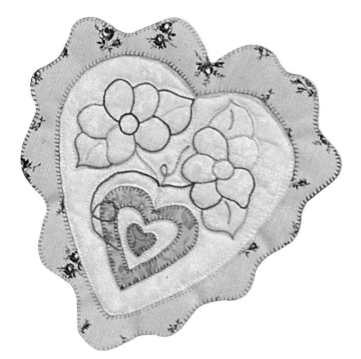

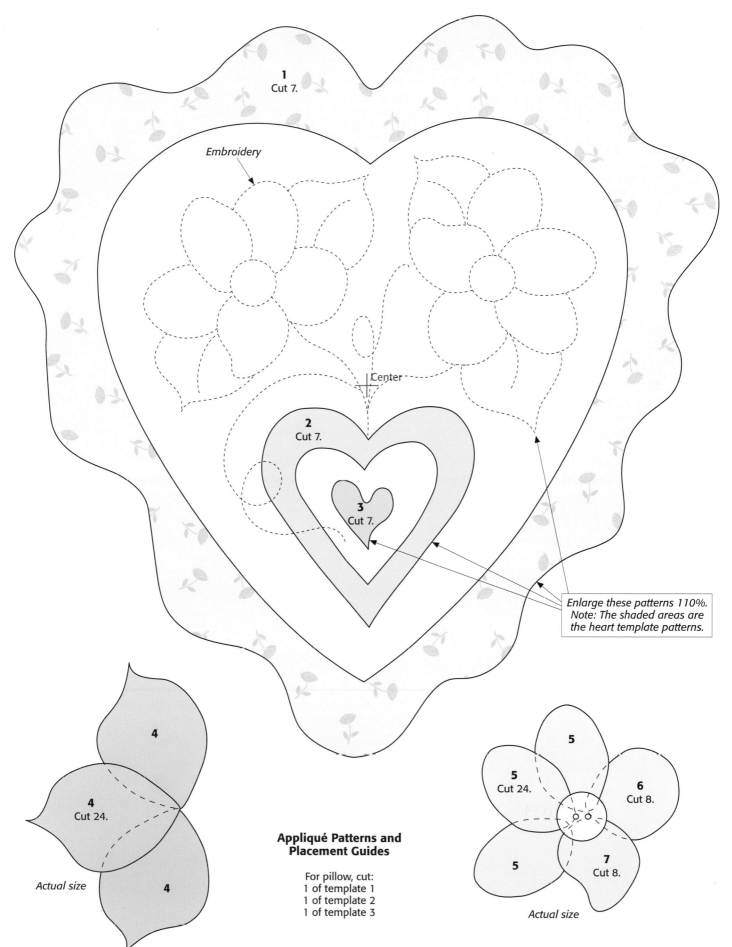

1
Cut 7.

Embroidery

Center

2
Cut 7.

3
Cut 7.

Enlarge these patterns 110%.
Note: The shaded areas are
the heart template patterns.

4

4
Cut 24.

4

Actual size

5

5
Cut 24.

6
Cut 8.

5

7
Cut 8.

Actual size

**Appliqué Patterns and
Placement Guides**

For pillow, cut:
1 of template 1
1 of template 2
1 of template 3

Nature's Whisper

Soft as a whisper they bloom,
Perfection for a moment in time.

Quilt size: 41" x 51"

Materials

Yardage is based on 42"-wide fabric.

❀ 1¾ yds. of pink floral print for center blocks, border 1, and border 5

❀ 1¾ yds. of light teal print for border 2 and border 4

❀ 1½ yds. of white fabric for background of center blocks and border 3

❀ ¼ yd. *each* of 2 green prints for leaves

❀ Fat quarters or ¼ yd. cuts of 4 yellow fabrics, 4 pink fabrics, 4 purple fabrics, and 4 blue fabrics for appliqué flowers

❀ 3 yds. of fabric for backing

❀ ½ yd. pink stripe for binding

❀ 51" x 61" piece of batting

❀ 6-strand embroidery floss (colors of your choice) for stems and vines

❀ Beads or buttons for embellishment (optional)

Cutting

All measurements include ¼" seam allowances.

From the white background fabric, cut on the lengthwise grain:

❀ 3 strips, 6" x 48"; cut the strips into 24 squares, 6" x 6"

❀ 2 strips, 5½" x approximately 28"

❀ 2 strips, 5½" x approximately 48"

From the pink floral print, cut:

❀ 2 strips on the lengthwise grain, 2½ " x 54"

❀ 3 strips, 2" x 42"; cut the strips into 48 squares, 2" x 2"

❀ 2 strips, 2" x approximately 23"

❀ 2 strips, 2" x approximately 36"

❀ 2 strips, 2½" x 42"

From the light teal print, cut:

❀ 2 strips, 1½" x approximately 26"

❀ 2 strips, 1½" x approximately 38"

❀ 2 strips, 1½" x approximately 39"

❀ 2 strips, 1½" x approximately 50"

From the pink stripe, cut:

❀ 2"-wide bias strips to total 198"

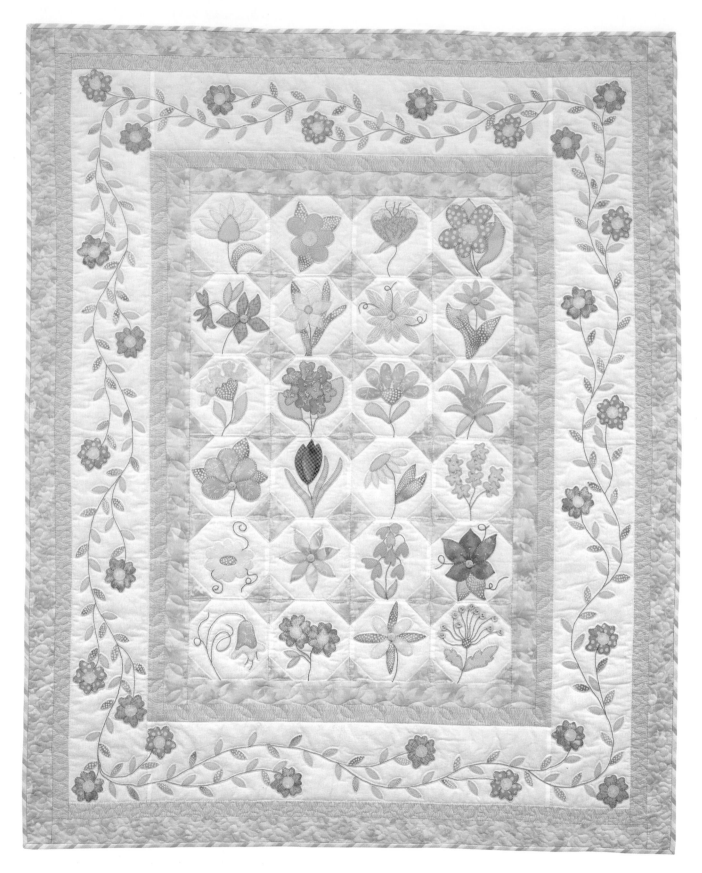

These sweet and soft flowers are as delicate as a springtime breeze. The appliqué is a breeze, too,
with the fusible-appliqué technique, but use any appliqué method you like. Incorporate some beads, buttons,
and textured threads to add depth and texture to this appealing quilt.

Assembling the Quilt

1. Choose your favorite appliqué method and make appliqué templates for the flowers and leaves by tracing the patterns beginning on page 47. Refer to "Appliqué" on page 13 for details as needed. Cut out the number of each shape indicated on the patterns.

2. Appliqué all the flowers and leaves to the white center blocks. Use a stem stitch and two strands of embroidery floss in your chosen color for the stems and vines. Refer to "Embroidery Stitches" on page 21.

3. Trim the 24 blocks to 5½" x 5½" by placing the 2¾" point of a square ruler on the center of the block. Trim the first two sides, then rotate the block and trim the remaining two sides.

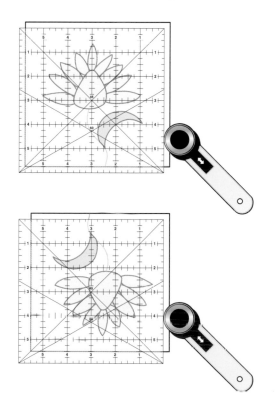

4. Place a pink floral square on each corner of the appliquéd blocks. Draw a diagonal line from corner to corner as shown. Stitch on the drawn line. Trim the seam allowance to ¼". Flip the triangles to the right side and press.

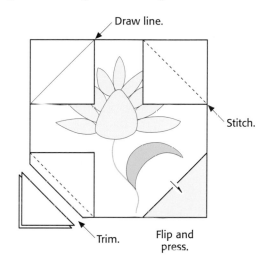

Draw line.

Stitch.

Trim.

Flip and press.

5. Sew the pieced blocks in six rows of four blocks each. Press the seams in opposite directions from row to row. Sew the rows together.

6. For border 1, measure across the center of your quilt. Cut the 2" x 23" pink floral strips to this measurement and sew to the top and bottom of the quilt. Press toward the border. To add the side borders, measure lengthwise through the center of your quilt. Cut the 2" x 36" pink floral strips to this measurement. Sew to the sides of the quilt. Press.

7. Repeat step 6 to add borders 2 and 3.

8. Use the border layout on page 59 and the photo on page 44 as a guide for placing the 26 flowers on the border. Appliqué the flowers and leaves.

FRIENDLY ADVICE

After you appliqué the flowers in position on the border, draw the vines from flower to flower (this will be your embroidery stitching guide); then appliqué the leaves along the vine.

9. Using two strands of embroidery floss in your chosen color, stem-stitch all the vines.

10. Repeat step 6 to add borders 4 and 5.

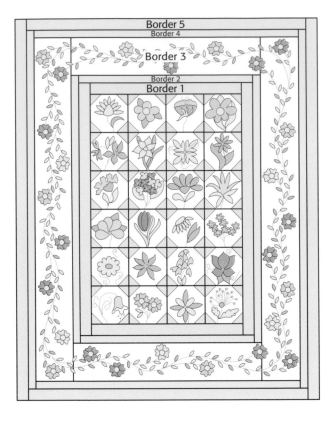

Finishing the Quilt

Refer to "Quilting and Finishing" on page 29 for more details if needed.

1. Mark a quilting design on the quilt top if desired. See the quilting suggestion below.

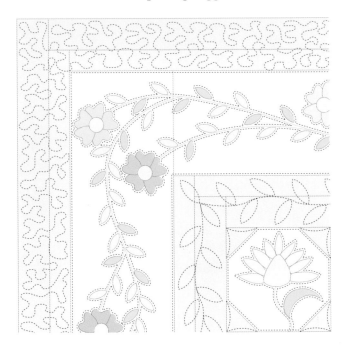

2. Layer the quilt top with batting and backing; baste.

3. Quilt by hand or machine.

4. Bind the edges of the quilt.

5. Add any embellishments, such as buttons and beads to the flowers, referring to "Embellishments" on page 20.

6. Add a label to the back of your quilt.

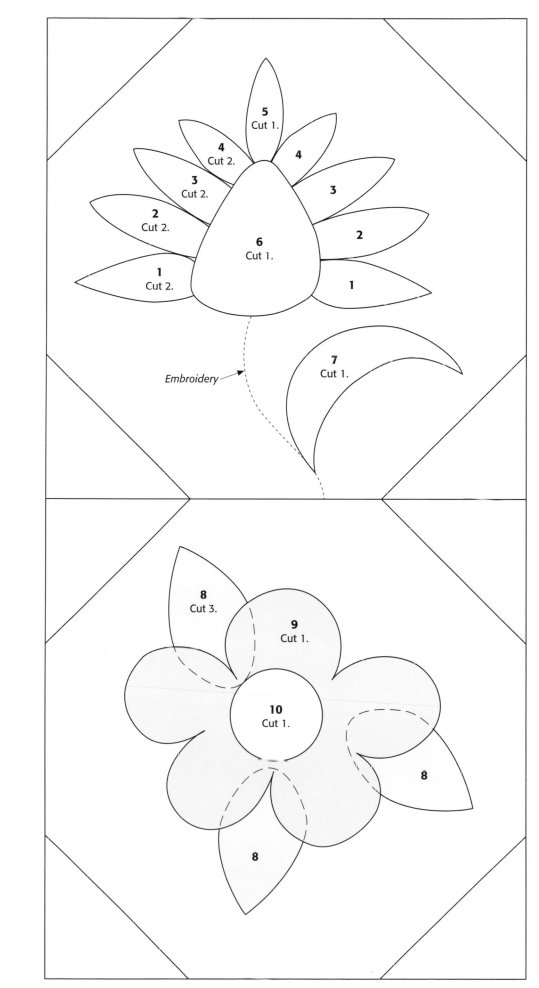

5
Cut 1.

4
Cut 2.

4

3
Cut 2.

3

2
Cut 2.

2

1
Cut 2.

6
Cut 1.

1

Embroidery

7
Cut 1.

Appliqué Patterns and Placement Guides

8
Cut 3.

9
Cut 1.

10
Cut 1.

8

8

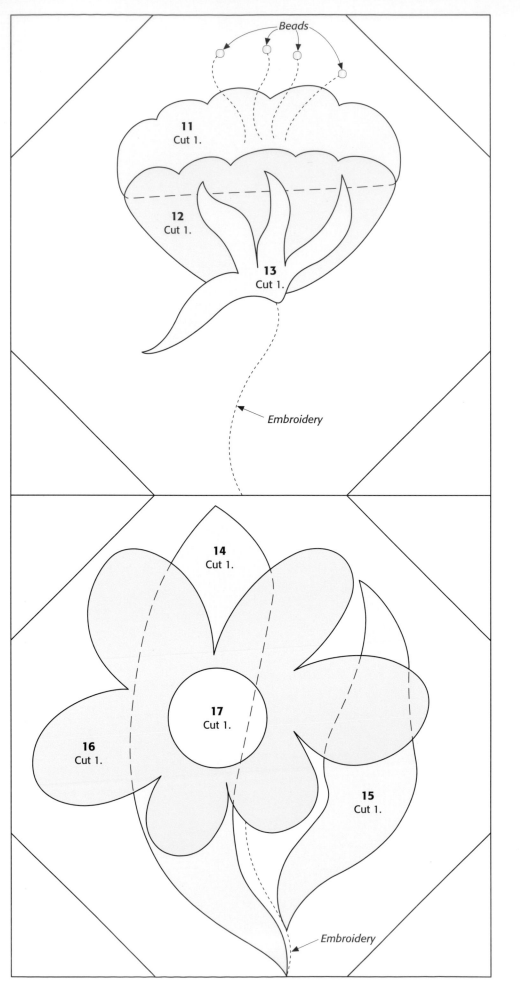

Beads

11
Cut 1.

12
Cut 1.

13
Cut 1.

Embroidery

**Appliqué Patterns and
Placement Guides**

14
Cut 1.

17
Cut 1.

16
Cut 1.

15
Cut 1.

Embroidery

· 48 ·

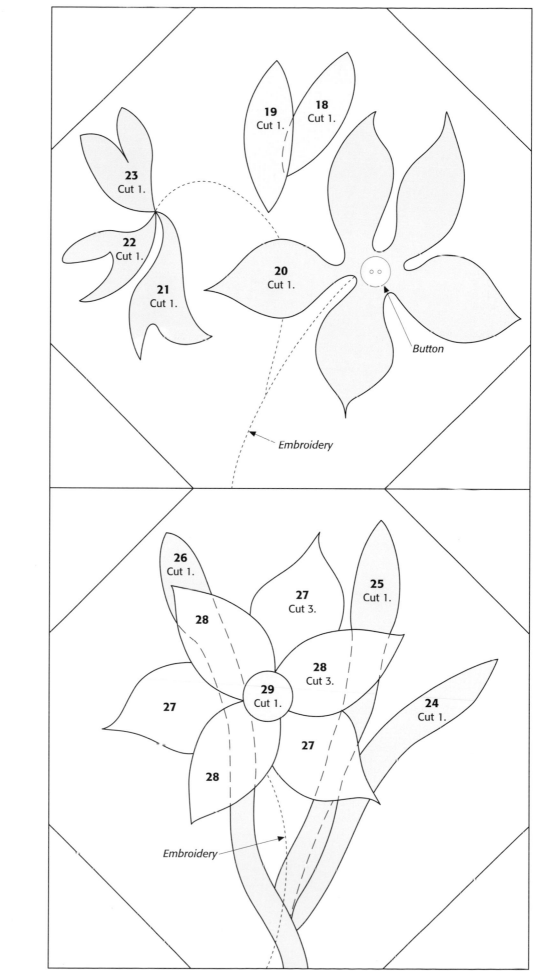

**Appliqué Patterns and
Placement Guides**

· 49 ·

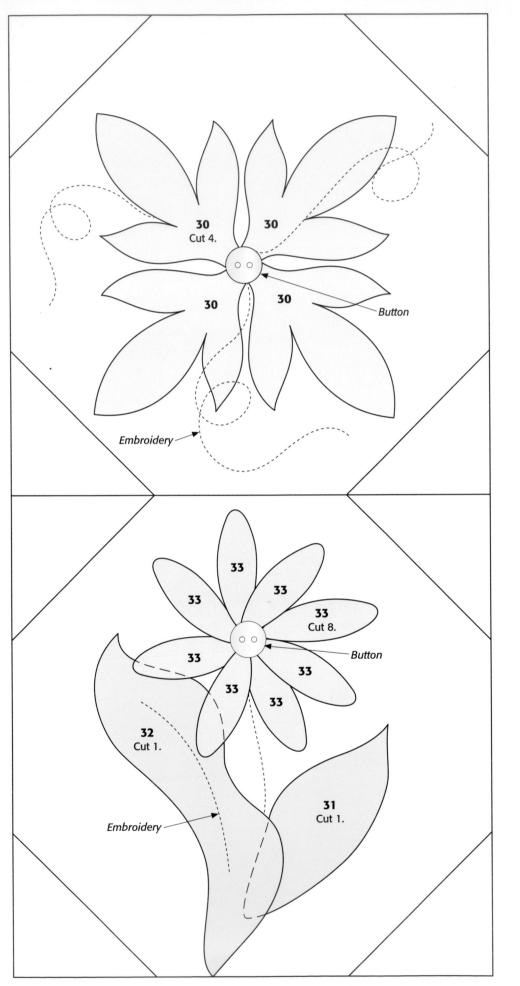

30
Cut 4.

30

30

30

Button

Embroidery

**Appliqué Patterns and
Placement Guides**

33

33

33

33

33
Cut 8.

33

Button

33

33

33

33

32
Cut 1.

31
Cut 1.

Embroidery

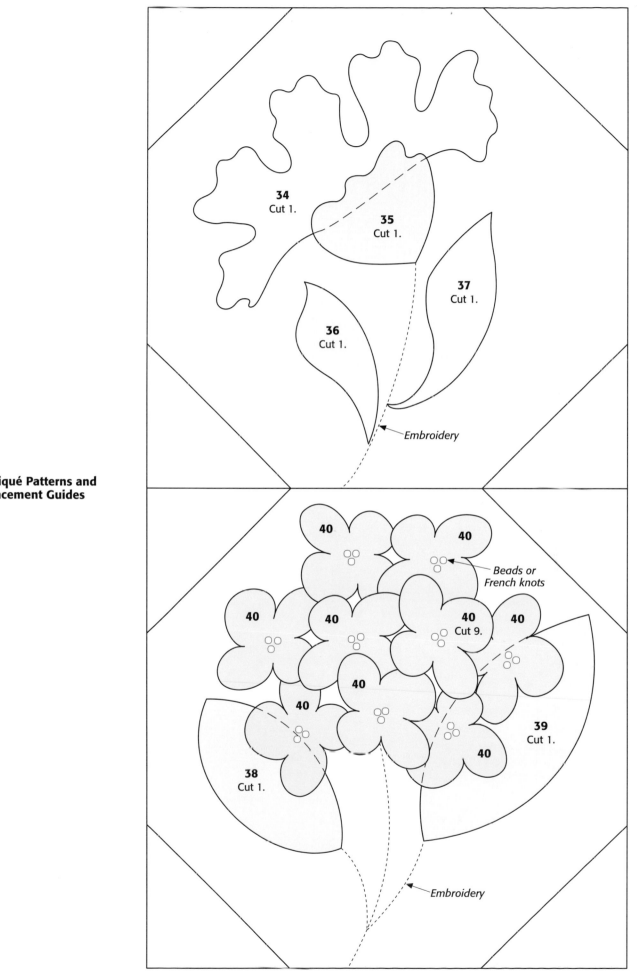

34
Cut 1.

35
Cut 1.

37
Cut 1.

36
Cut 1.

← *Embroidery*

Appliqué Patterns and Placement Guides

40

40

← *Beads or French knots*

40

40

40
Cut 9.

40

40

40

40

39
Cut 1.

38
Cut 1.

40

← *Embroidery*

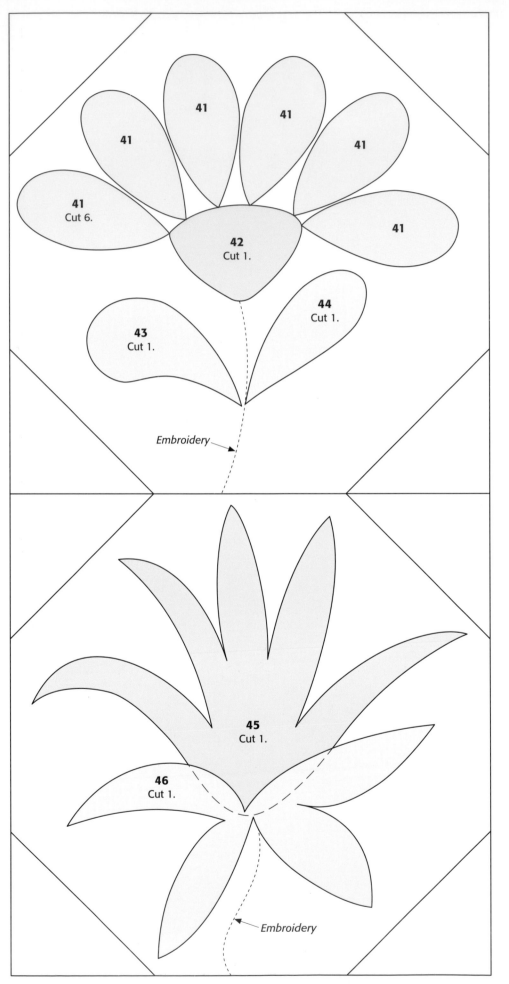

41
Cut 6.

41

41

41

41

41

42
Cut 1.

43
Cut 1.

44
Cut 1.

Embroidery

45
Cut 1.

46
Cut 1.

Embroidery

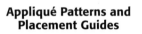

**Appliqué Patterns and
Placement Guides**

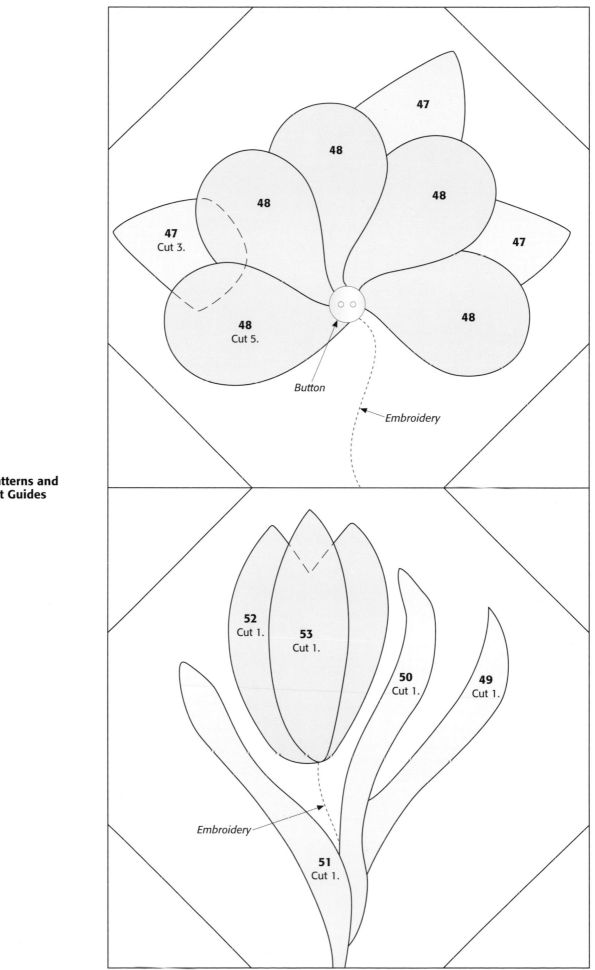

Appliqué Patterns and Placement Guides

47
Cut 3.

47

48

48

48

48

48
Cut 5.

48

Button

Embroidery

52
Cut 1.

53
Cut 1.

50
Cut 1.

49
Cut 1.

51
Cut 1.

Embroidery

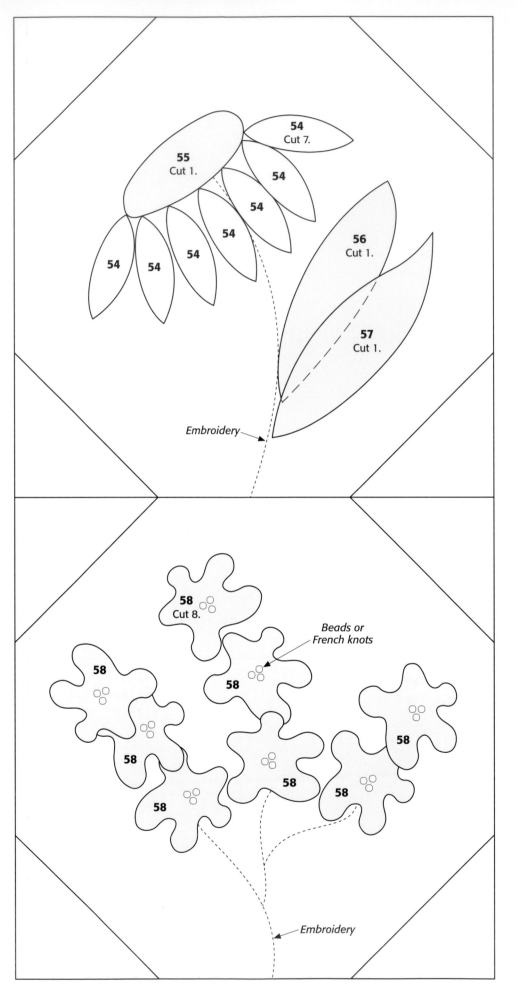

54
Cut 7.

55
Cut 1.

54

54

54

54

54

54

54

56
Cut 1.

57
Cut 1.

Embroidery

**Appliqué Patterns and
Placement Guides**

58
Cut 8.

*Beads or
French knots*

58

58

58

58

58

58

58

Embroidery

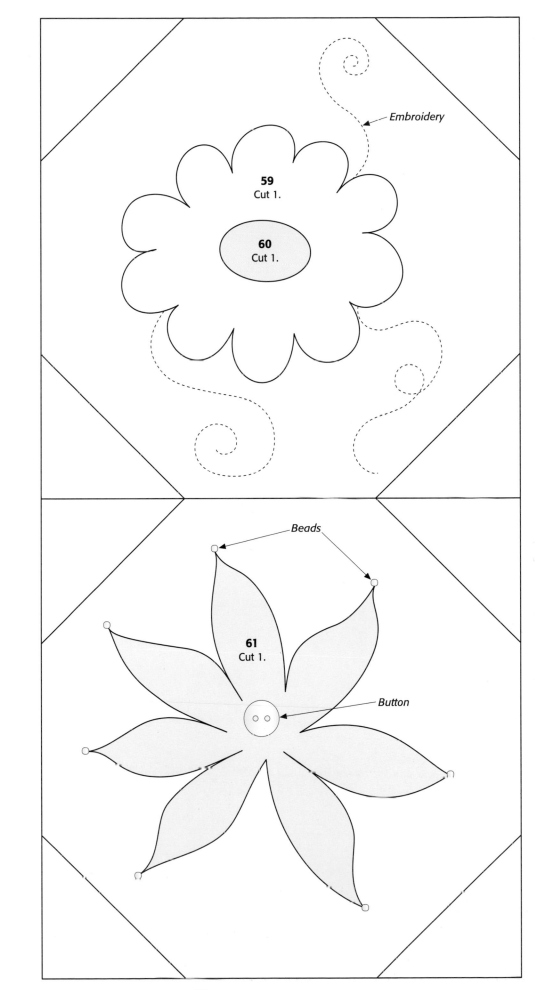

Appliqué Patterns and Placement Guides

Embroidery

59
Cut 1.

60
Cut 1.

Beads

61
Cut 1.

Button

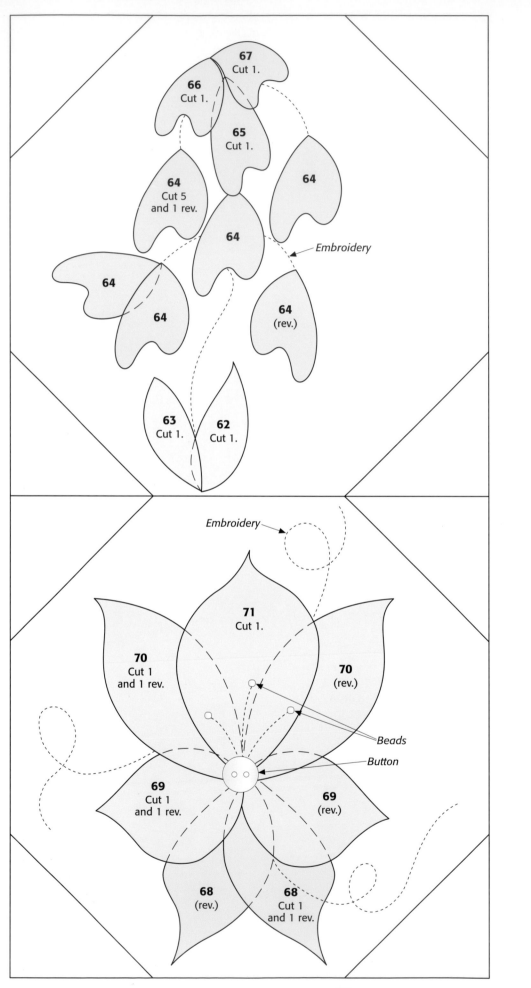

Appliqué Patterns and Placement Guides

67
Cut 1.

66
Cut 1.

65
Cut 1.

64
Cut 5
and 1 rev.

64

64

64

Embroidery

64

64
(rev.)

63
Cut 1.

62
Cut 1.

Embroidery

71
Cut 1.

70
Cut 1
and 1 rev.

70
(rev.)

Beads

Button

69
Cut 1
and 1 rev.

69
(rev.)

68
(rev.)

68
Cut 1
and 1 rev.

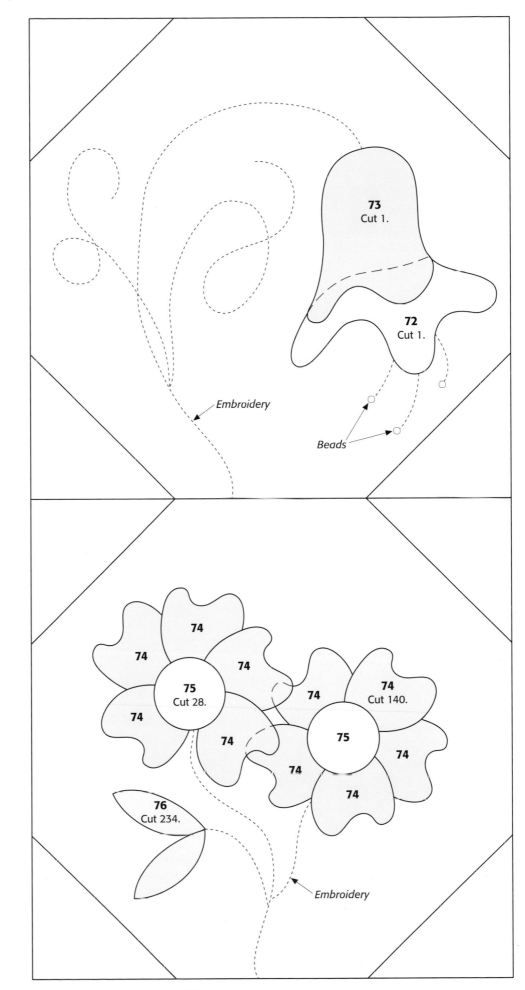

Appliqué Patterns and Placement Guides

Use these flower and leaf patterns for the border.

73
Cut 1.

72
Cut 1.

Embroidery

Beads

74

74

74

75
Cut 28.

74

74

74

74
Cut 140.

74

75

74

74

76
Cut 234.

Embroidery

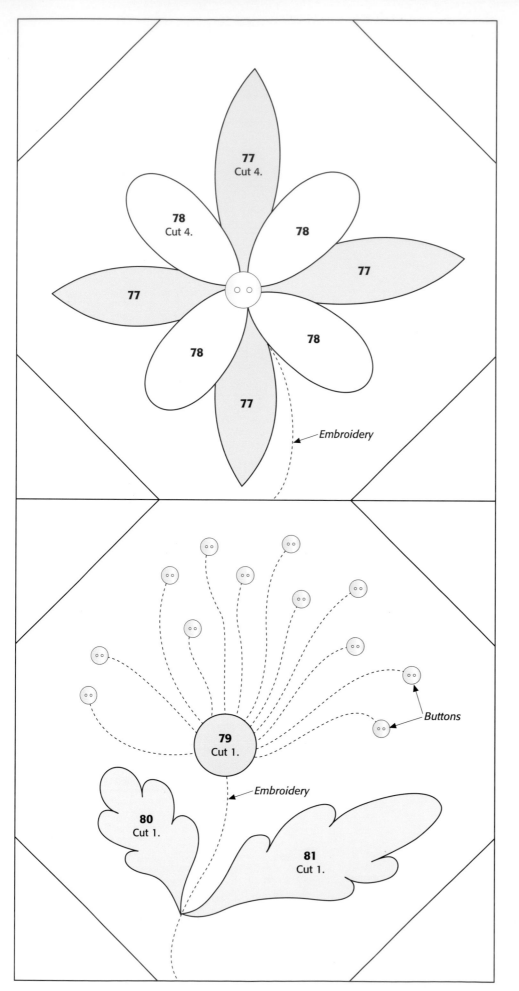

77
Cut 4.

78
Cut 4.

78

77

77

78

78

77

Embroidery

Appliqué Patterns and Placement Guides

79
Cut 1.

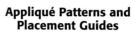

Buttons

Embroidery

80
Cut 1.

81
Cut 1.

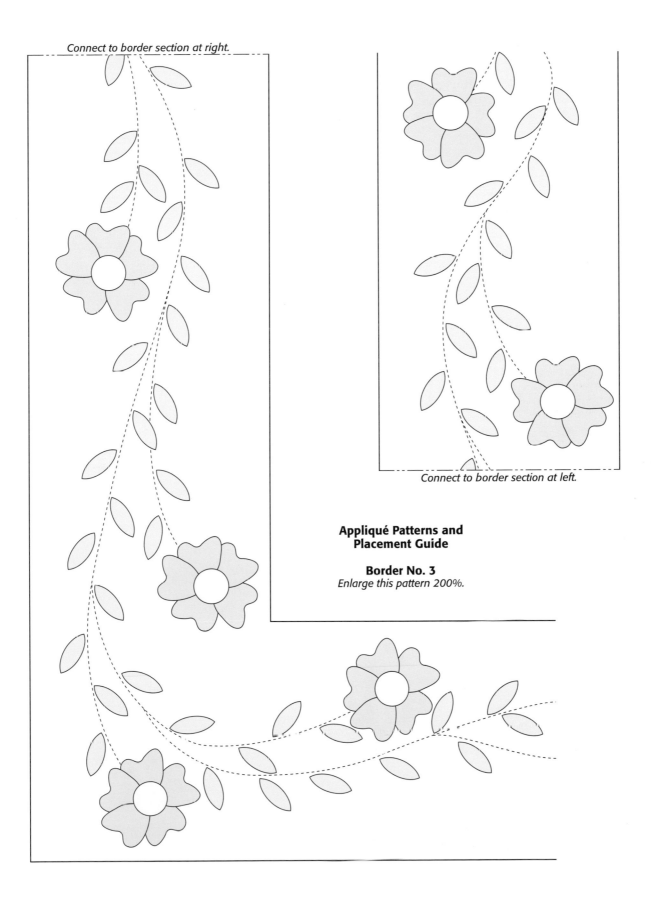

Connect to border section at right.

Connect to border section at left.

Appliqué Patterns and Placement Guide

Border No. 3
Enlarge this pattern 200%.

Fragrant Memories

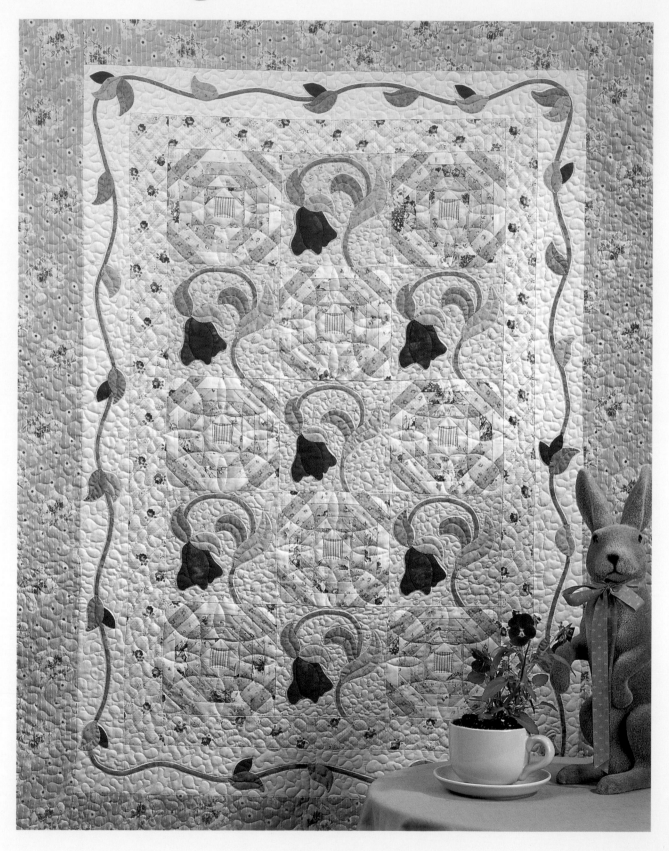

When times were gentle,
And the veranda was used,
When days were long,
And love was new.

Quilt size: 41" x 55"

Materials

Yardage is based on 42"-wide fabric.

❀ 2 yds. of pink floral stripe for border 3

❀ 1½ yds. of unbleached muslin for border 2 and pieced blocks

❀ ⅝ yd. of pink floral print for background of appliqué blocks

❀ ⅝ yd. of pink floral plaid for border 1 and pieced blocks

❀ ½ yd. of green print 1 for stems and vines

❀ ½ yd. of green print 2 for pieced blocks and binding

❀ Fat quarters or ¼ yd. cuts of 8 different pink prints for pieced blocks

❀ ¼ yd. of dark pink hand-dyed fabric for flowers

❀ ¼ yd. *each* of 2 green prints for leaves

❀ ⅛ yd. of green stripe for pieced blocks

❀ 3¼ yds. of fabric for backing

❀ Batting, 51" x 65"

Cutting

All measurements include ¼" seam allowances.

From green print 1, cut:

❀ 7 bias strips, ½" x 13"

❀ ½"-wide bias strips to total 200"

From the pink floral print, cut:

❀ 7 squares, 7½" x 7½"*

From the green stripe, cut:

❀ 8 squares, 2¼" x 2¼"

From the pink floral plaid, cut:

❀ Several 1¾" x 42" strips

❀ 2 strips, 3" x approximately 23"

❀ 2 strips, 3" x approximately 42"

**You may want to cut your blocks ½" oversize and trim to 7½" square after appliquéing the design.*

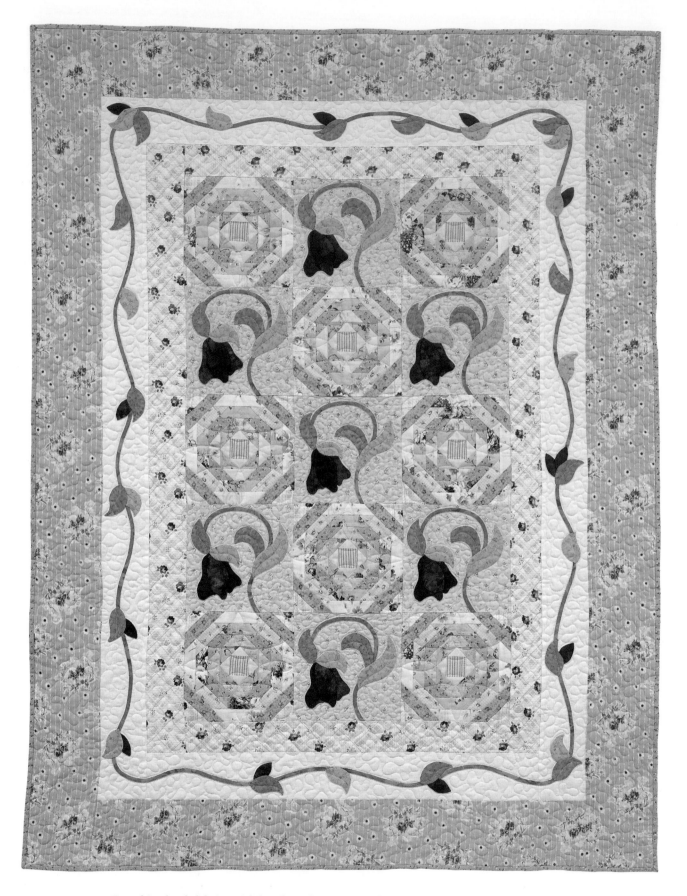

I combined soft fabrics with hand appliqué to give this quilt a captivating, antique look.
The subtle, paper-pieced blocks add to the gentle charm and vintage look of this quilt.

From *each* of the 8 pink prints, cut:

❋ Several 1¾" x 21" or 1¾" x 42" strips

From the unbleached muslin, cut on the lengthwise grain:

❋ Several 1¾" x 47" strips

❋ 2 strips, 3½" x approximately 27"

❋ 2 strips, 3½" x approximately 47"

From the pink floral stripe, cut on the lengthwise grain:

❋ 2 strips, 5" x approximately 34"

❋ 2 strips, 5" x approximately 57"

From green print 2, cut:

❋ Several 1¾" x 42" strips

❋ 5 strips, 2" x 42"

Making the Blocks

1. Choose your favorite appliqué method. Make appliqué templates for the flowers and leaves by tracing the template patterns on page 66. Refer to "Appliqué" on page 13 for details as needed. Cut out the number of each shape indicated on the patterns.

2. Refer to "Making Bias Vines" on page 00 to make ¼"-wide bias stems from the 13"-long green print bias strips. Using the block layout on page 66 as a guide, position and pin the stems in place on the background. Appliqué the stems.

3. Position and appliqué the flowers to the background.

4. Appliqué all the leaves.

5. Make eight paper foundations, using the block pattern on page 65. Refer to "Paper Piecing" on page 26 for further details.

6. Paper-piece eight blocks, beginning with the green stripe square in the middle.

Assembling the Quilt

1. Sew the blocks together in five rows of three blocks each; press the seams in opposite directions from row to row. Sew the rows together.

2. To add the top and bottom border 1, measure across the center of your quilt. Cut the 3" x 23" pink floral plaid strips to this measurement. Sew the strips to the top and bottom of the quilt. Press the seams toward the borders. To add the side borders, measure lengthwise through the center of your quilt. Cut the 3" x 42" pink floral plaid strips to this measurement; scw to the sides of the quilt. Press.

3. Repeat step 2 to add borders 2 and 3.

4. Make a ¼"-wide bias vine from the ½"-wide green print 1 bias strips. Using the photo on page 62 as a guide, position the vines in border 2 and pin in place. Appliqué the vines.

5. Position the buds and leaves; pin and appliqué them in place.

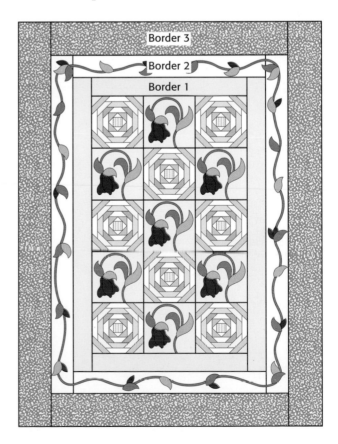

Finishing the Quilt

Refer to "Quilting and Finishing" on page 29 for more details if needed.

1. Mark a quilting design on the quilt top if desired. See the quilting suggestion below.

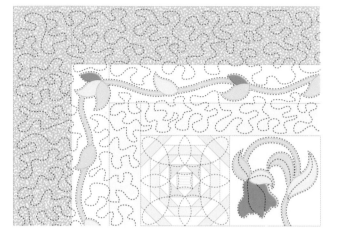

2. Layer the quilt top with batting and backing; baste.

3. Quilt by hand or machine.

4. Bind the edges of the quilt.

5. Add a label to the back of your quilt.

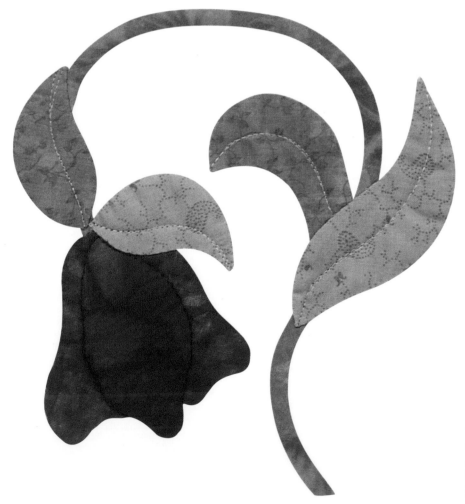

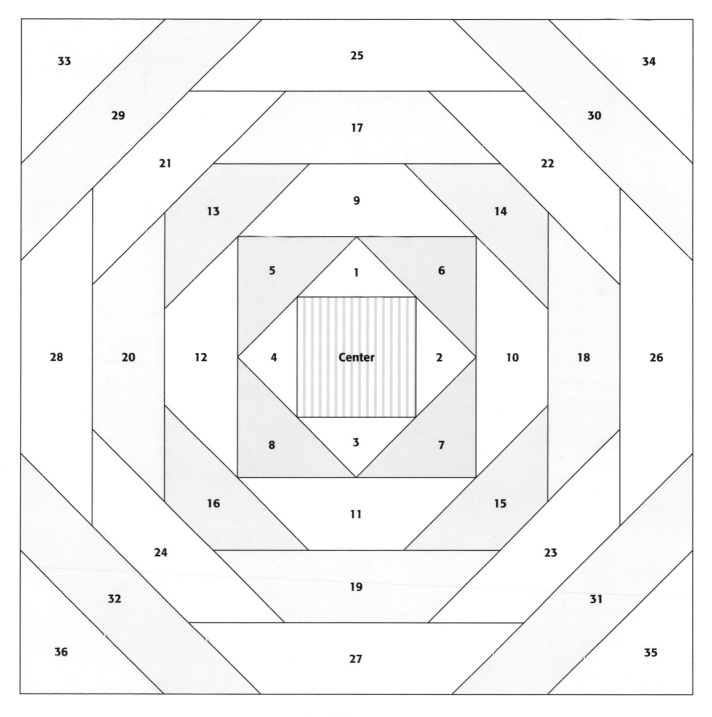

Foundation Pattern

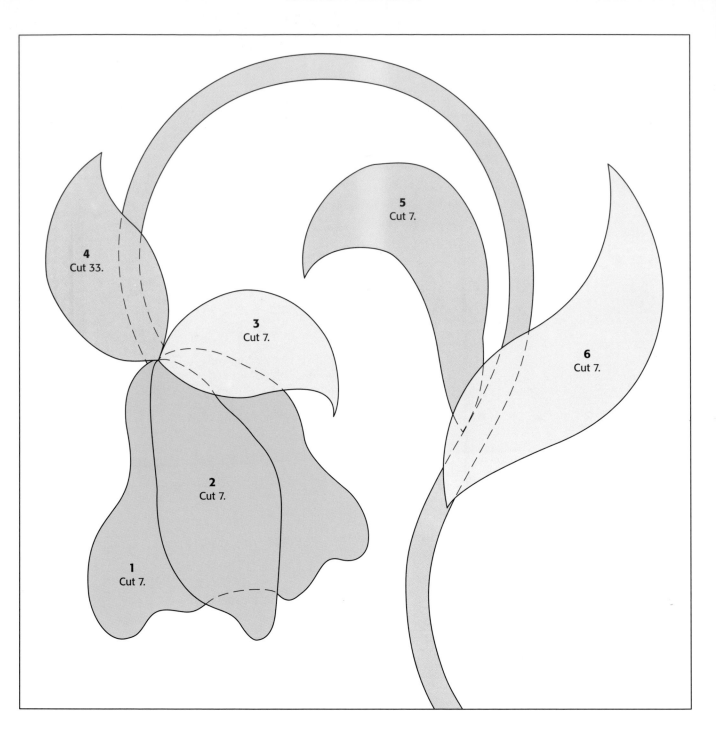

4
Cut 33.

5
Cut 7.

3
Cut 7.

6
Cut 7.

2
Cut 7.

1
Cut 7.

**Appliqué Patterns and
Placement Guides**

Border 2

4

7
Cut 12.

Pockets of Posies

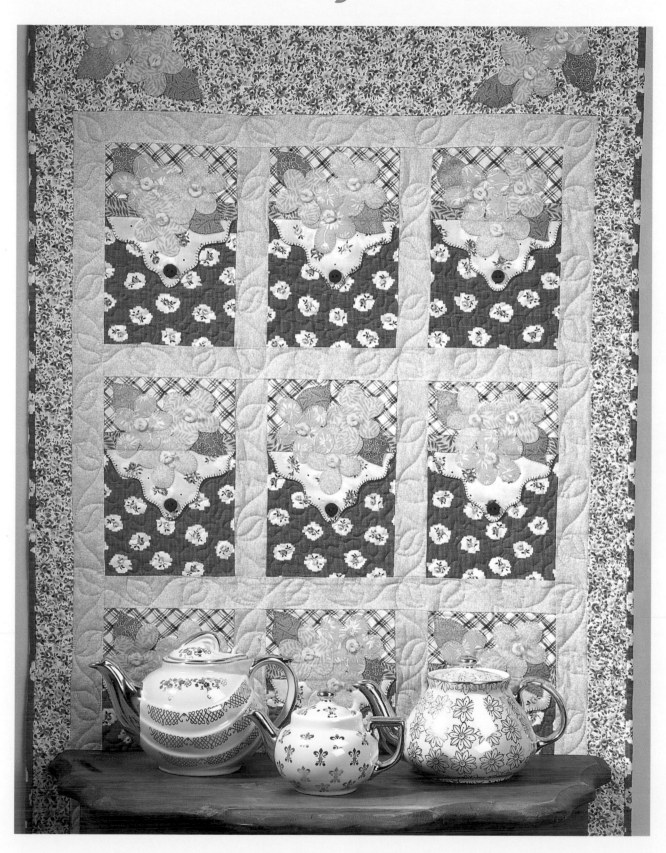

That wonderful combination of blue and yellow fabrics makes this a bright and happy quilt.
I used fusible appliqué, but any method will work.

Accept this poesy from a Friend
Whose love will never end.

Lucy A. Sianiho's Sampler (1918, age 14)
from *Needles & Friends*, edited and published by Denise May-Levenick (1983)

Quilt size: 28" x 41"

Materials

Yardage is based on 42"-wide fabric.

* ¾ yd. of dark blue floral print for blocks and binding
* ¾ yd. of yellow print 1 for sashing, border 1, and flowers
* ½ yd. of medium blue floral print for border 2
* ¼ yd. of white floral print for blocks
* ¼ yd. of light blue floral print for blocks
* ¼ yd. of blue-and-white plaid for blocks

* ¼ yd. *each* of yellow print 2 and yellow print 3 for flowers
* ¼ yd. *each* of 3 green prints for leaves
* 1⅝ yds. of fabric for backing
* 38" x 51" piece of batting
* 31 yellow buttons, ⅝" diameter, for flower centers
* 9 blue buttons, ½" diameter, for pocket fronts
* 2 yellow tassels (optional)

Cutting

All measurements include ¼" seam allowances.

From the dark blue floral print, cut:
* 9 rectangles, 6¼" x 6½"
* 4 strips, 2" x 42"

From the blue-and-white plaid, cut:
* 2 strips, 3" x 42"; cut the strips into 9 rectangles, 3" x 6½"

From the light blue floral print, cut:
* 2 strips, 1¼" x 42"; cut the strips into 9 rectangles, 1¼" x 6½"

From yellow print 1, cut:
* 2 strips, 2" x 42"; cut the strips into 6 rectangles, 2" x 9½"
* 4 strips, 2" x approximately 23"
* 2 strips, 2" x approximately 35"

From the medium blue floral print, cut:

* ❁ 1 strip, 2½" x approximately 26"
* ❁ 2 strips, 2½" x approximately 37"
* ❁ 1 strip, 6½" x approximately 30"

> ### FRIENDLY ADVICE
>
> *This quilt would be perfect for incorporating vintage fabrics. If you have some linen or handkerchief fabrics or flour sacks, try using them for the pocket fronts or in the pieced backgrounds.*

Making the Blocks

1. Choose your favorite appliqué method and make templates for the pocket fronts, flowers, and leaves by tracing the patterns on page 72. Refer to "Appliqué" on page 13 for details as needed. Cut out the number of each shape indicated on the patterns.

2. Position the pocket-front appliqué shape on the dark blue floral rectangles. Align it at the top, along a 6½" edge. The top raw edge of the appliqué will be sewn into the seam when the backgrounds are pieced together. Appliqué the pocket front to the background along the bottom edge.

3. Piece the nine background blocks by sewing the blue-and-white plaid, light blue floral, and dark blue floral rectangles together.

Make 9.

4. Position and appliqué the leaves on each block.

5. Appliqué the flowers in position.

Assembling the Quilt

1. Arrange the blocks into three rows of three blocks each, with yellow sashing strips, 2" x 9½", placed between the blocks. Sew the blocks together in rows; press the seams toward the pieced blocks (seams pressed toward the yellow sashing would show through and detract from the quilt's appearance).

2. Sew the three rows together, placing a sashing strip between each row. To determine the length of the sashing strips, measure across the center of the rows. Cut the four yellow 2" x 23" strips to this measurement. Sew. Press the seams toward the blocks.

3. Sew two of the yellow strips you just cut to the top and bottom of the quilt. Press the seams toward the blocks.

4. Measure lengthwise through the center of your quilt. Cut the two yellow 2" x 35" strips to this measurement. Sew the strips to the sides of your quilt. Press the seams toward the blocks.

5. To add the bottom border 2, measure across the center of your quilt. Cut the medium blue 2½" x 26" strip to this measurement. Sew to the bottom of the quilt. Press the seams toward border 2.

6. To add the side borders 2, measure lengthwise through the center of your quilt. Cut the two medium blue 2½" x 37" strips to this measurement. Sew the strips to the sides of the quilt. Press toward border 2.

7. To add the top border 2, measure across the center of your quilt. Cut the medium blue 6½" x 30" strip to this measurement. Sew to the top of the quilt. Press toward border 2.

8. Using the placement guide on page 73 and referring to the photo, position and appliqué the leaves and flowers to the top of border 2.

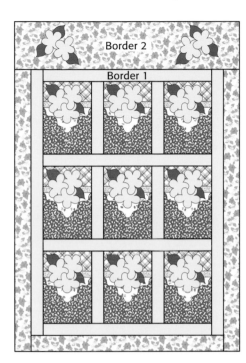

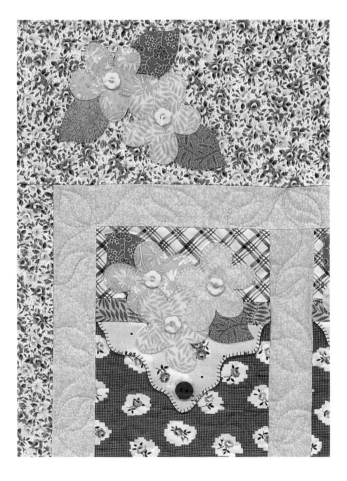

Finishing the Quilt

Refer to "Quilting and Finishing" on page 29 for more details if needed.

1. Mark a quilting design on the quilt top if desired. See the quilting suggestion below.

2. Layer the quilt top with batting and backing; baste.

3. Quilt by hand or machine.

4. Bind the edges of the quilt. If you want to add the optional yellow tassels, add them to the corners as you hand stitch the binding in position.

5. Add a label to the back of your quilt.

6. Sew buttons in the centers of the flowers and on the pocket fronts. Refer to "Embellishments" on page 20.

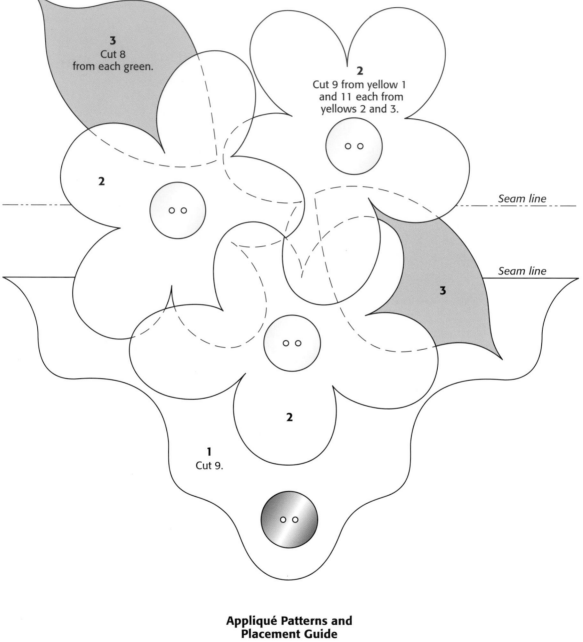

3
Cut 8
from each green.

2
Cut 9 from yellow 1
and 11 each from
yellows 2 and 3.

2

Seam line

Seam line

3

2

1
Cut 9.

**Appliqué Patterns and
Placement Guide**

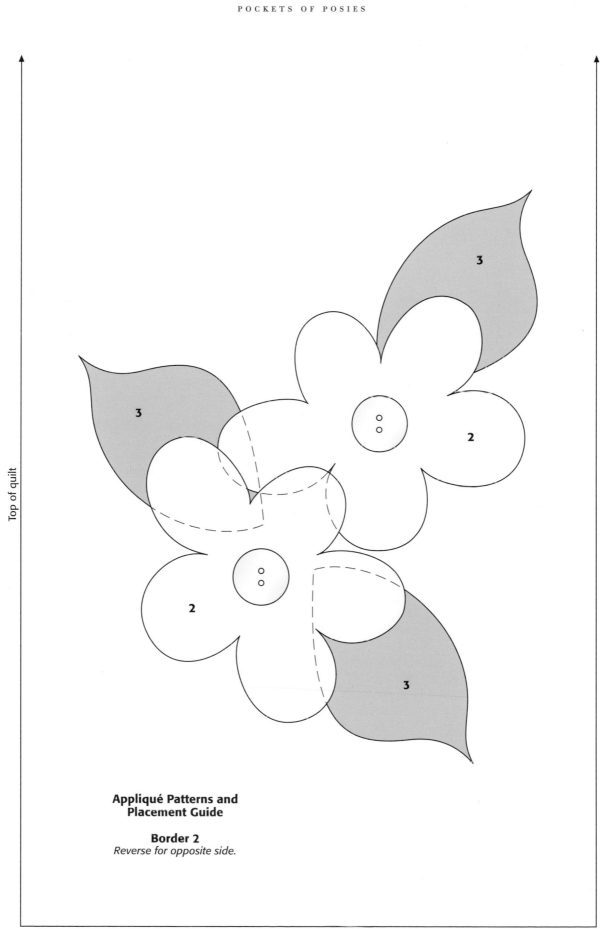

Top of quilt

**Appliqué Patterns and
Placement Guide**

Border 2
Reverse for opposite side.

Top left edge of quilt

My Heart's in the Garden

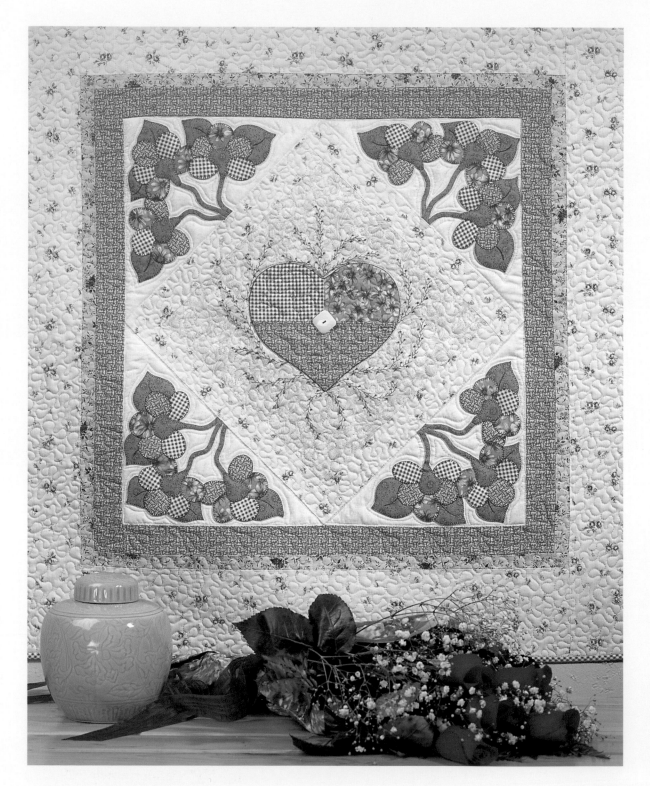

Wherever I go
Whatever I do
My heart's in the garden
And I'm dreaming of you

Quilt size: 36" x 36"

Materials

Yardage is based on 42"-wide fabric.

- ¾ yd. of yellow-and-red floral print for center and border 3
- ½ yd. of light green print for center square
- ½ yd. of red check for center heart, flowers, and binding
- ½ yd. of red print 1 for center heart, flowers, and border 1
- ½ yd. of yellow print for corner triangles
- ¼ yd. of red print 2 for center heart and flowers

- ¼ yd. of green print for bias stems, flower centers, and leaves
- ¼ yd. of beige floral print for border 2
- 2½ yds. of fabric for backing
- 46" x 46" piece of batting
- Red and green 6-strand embroidery floss for heart, leaves, and vines
- 1"-diameter button for center heart
- Small red beads for center vines

Cutting

All measurements include ¼" seam allowances.

From the red check, cut:
- 1 square, 5½" x 5½"
- 4 strips, 2" x 42"

From red print 2, cut:
- 1 square, 5½" x 5½"

From red print 1, cut:
- 1 rectangle, 5½" x 10½"
- 2 strips, 2" x approximately 24"
- 2 strips, 2" x approximately 27"

From the light green print, cut:
- 1 square, 12½" x 12½"

From the yellow-and-red floral print, cut:
- 2 strips, 2" x 12½"
- 2 strips, 2" x 15½"
- 2 strips, 5½" x approximately 28"
- 2 strips, 5½" x approximately 38"

If you're like me, this sweet quilt will combine all your favorite things: patchwork, appliqué, hearts, flowers, embroidery, buttons, and beads! The feather-stitched vines with small red beads add a delicate and extra-special touch.

From the green print, cut:
* ½"-wide bias strips to total 50"

From the yellow print, cut:
* 2 squares, 11½" x 11½"; cut in half diagonally once to make 4 triangles

From the beige floral print, cut:
* 2 strips, 1¼" x approximately 27"
* 2 strips, 1¼" x approximately 28"

Assembling the Quilt

1. Choose your favorite appliqué method and make templates for the heart, flowers, and leaves by tracing the patterns on pages 79 and 80. Refer to "Appliqué" on page 13 for details as needed. Cut out the number of each shape indicated on the patterns.

2. Sew the 5½" red check and red print 2 squares and the 5½" x 10½" red print 1 rectangle together to form a square. From this square, cut one heart, using template 1.

3. Appliqué the heart from step 2 in the center of the light green square. Please note that the center square is set on point.

4. Use a stem stitch around the outer edge of the center heart to make it stand out. Refer to "Embroidery Stitches" on page 21.

5. Use a feather stitch for the vines around the heart, following the embroidery pattern on page 79 as a guide for making your vines wander. Refer to "Embroidery Stitches" on page 21.

6. Sew the 2" x 12½" yellow-and-red floral strips to two opposite sides of the green center square. Press the seams toward the strips. Sew the 2" x 15½" yellow-and-red floral strips to the remaining sides of the green center square. Press.

7. From the ½"-wide bias strips, make twelve ¼"-wide bias stems approximately 4" long. Refer to "Making Bias Vines" on page 19. Using the placement guide on page 80, appliqué the stems in position on the yellow print triangle. The raw edges of the stems will be sewn into the seam when the triangle is joined to the center square.

FRIENDLY ADVICE

Handle the background triangles very carefully to avoid stretching the long bias edge. You may want to sew the triangle to the center square after appliquéing the stems. Then appliqué the flowers and leaves.

8. Appliqué the leaves, flowers, and flower centers in position using the appliqué placement guide on page 80.

9. Use a stem stitch for the center veins of each leaf.

10. Sew the corner triangles to the four sides of the center square. Press the seams toward the yellow-and-red floral strips.

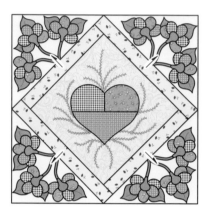

11. To add the top and bottom border 1, measure across the center unit. Cut the 2" x 24" red print strips to this measurement. Sew to the top and bottom of the center unit. Press toward border 1. To add the side borders, measure lengthwise through the center unit. Cut the 2" x 27" red print strips to this measurement. Sew to the sides of the quilt. Press.

12. Repeat step 11 to add borders 2 and 3.

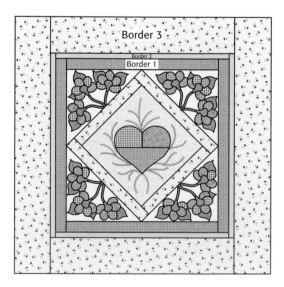

Finishing the Quilt

Refer to "Quilting and Finishing" on page 29 for more details if needed.

1. Mark a quilting design on the quilt top if desired. See the quilting suggestion below.

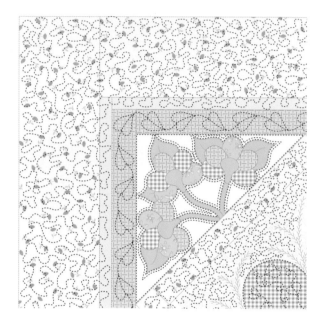

2. Layer the quilt top with batting and backing; baste.

3. Quilt by hand or machine.

4. Bind the edges of the quilt.

5. Add a label to the back of your quilt.

6. Sew a 1"-diameter button to the center of the heart. Sew small red beads to the vines around the heart, hiding your thread between the layers of the quilt. Refer to "Embellishments" on page 20.

Embroidery guide lines

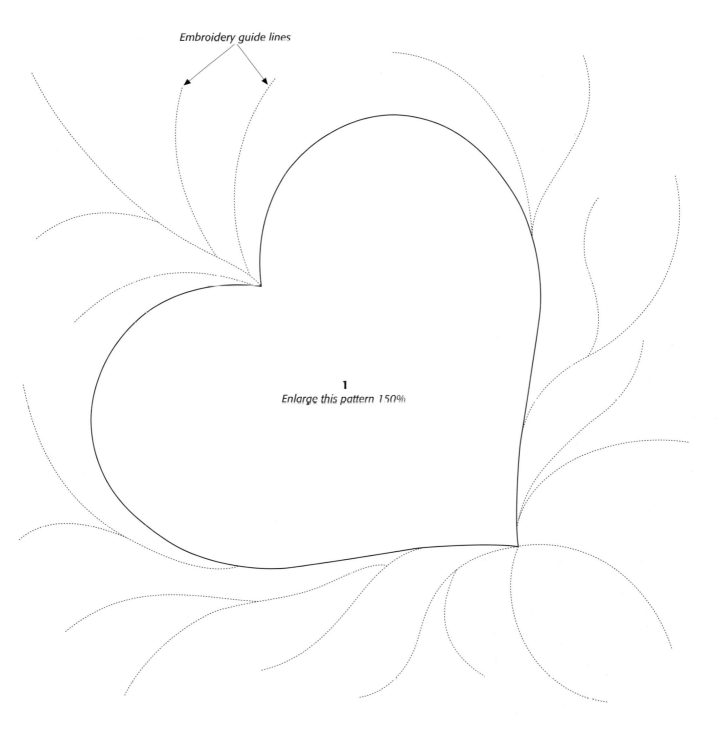

1
Enlarge this pattern 150%

**Appliqué Pattern and
Embroidery Placement Guide**

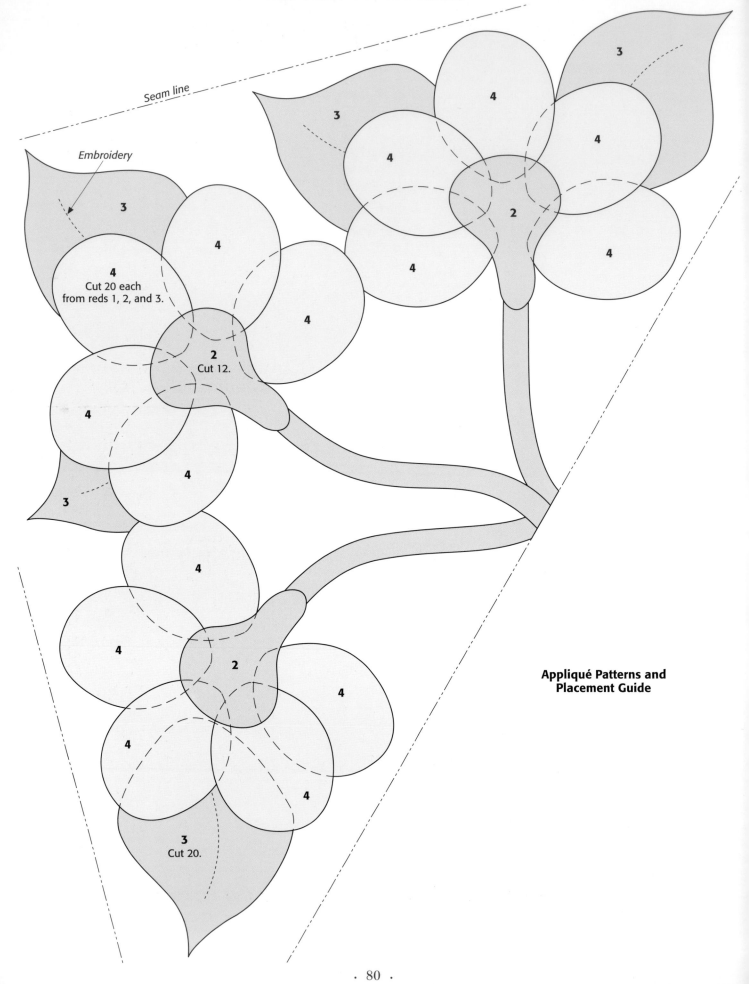

Seam line

Embroidery

3

4

4
Cut 20 each
from reds 1, 2, and 3.

4

4

4

2
Cut 12.

4

3

4

4

3

4

4

4

2

4

4

4

3
Cut 20.

3

4

4

4

3

4

4

4

2

4

4

**Appliqué Patterns and
Placement Guide**

Dance of the Flowers

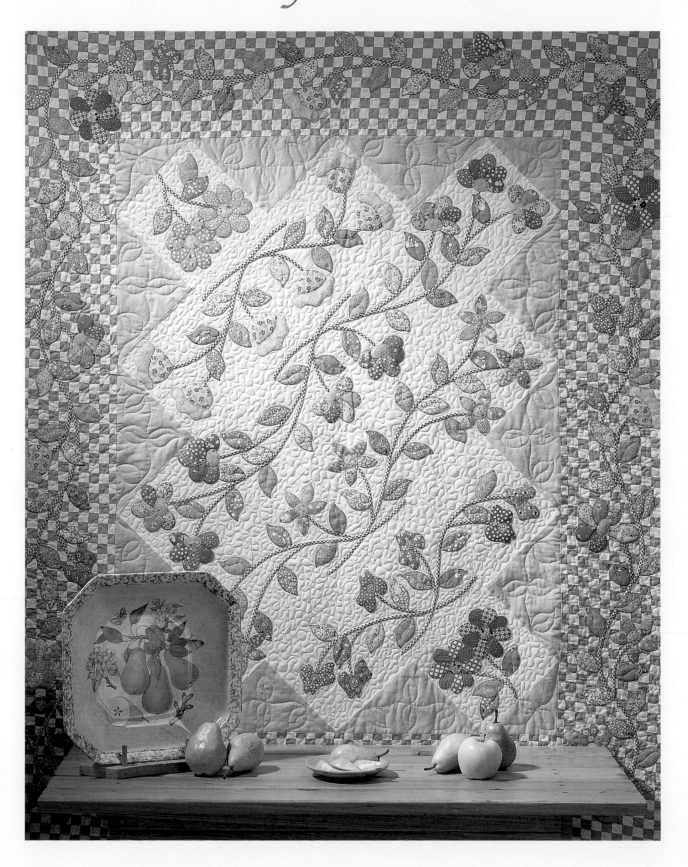

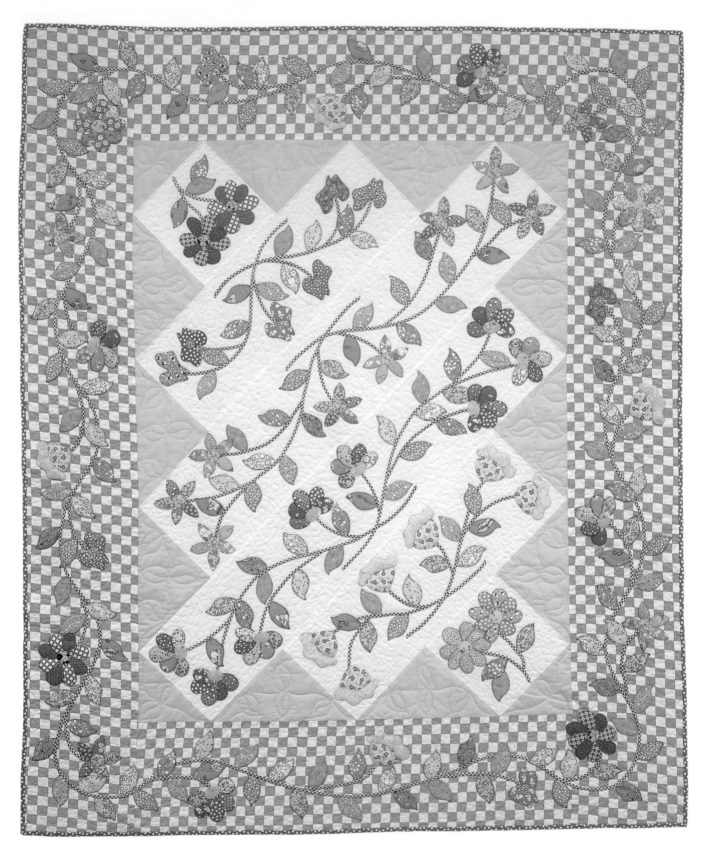

Who can resist this lovely quilt made of 1930s reproduction fabrics? A wide variety
of colors and prints give this quilt an old-time look, but the diagonal strips of
graceful appliqué give it a refined and appealing country charm as well.

A dip to the left, a sway to the right,
They dance on the wind, so happy and bright!

Quilt size: 52" x 63"

Materials

Yardage is based on 42"-wide fabric.

- 2⅛ yds. of green plaid for border
- 1⅜ yds. of white fabric for center strips
- 1 yd. of red plaid for bias vines
- ¾ yd. of yellow fabric for quilt center
- Fat quarters or scraps of 12 different green 1930s reproduction prints for leaves
- Fat quarters or scraps of 8 different orange 1930s reproduction prints for flowers
- Fat quarters or scraps of 6 different yellow 1930s reproduction prints for flowers and flower centers
- Fat quarters or scraps of 10 different pink 1930s reproduction prints for flowers
- Fat quarters or scraps of 6 different blue 1930s reproduction prints for flowers
- Fat quarters or scraps of 10 different purple 1930s reproduction prints for flowers
- Fat quarter or scrap of 1 brown 1930s reproduction print for flower centers
- 4 yds. of fabric for backing
- ½ yd. of purple 1930s reproduction print for binding
- 62" x 73" piece of batting

Cutting

All measurements include ¼" seam allowances.

From the red plaid, cut:
- ½"-wide bias strips to total approximately 700"

From the white fabric, cut:*
- 2 squares, 8½" x 8½"
- 2 strips, 8½" x 24½"
- 2 strips, 8½" x 40½"

From the yellow fabric, cut:
- 2 squares, 6½" x 6½"; cut in half diagonally once to make 4 half-square triangles
- 3 squares, 12⅝" x 12⅝"; cut in half diagonally twice to make 12 quarter-square triangles. You will need only 10.

**Before you cut, see if you can cut the 40½" strips across the width of the fabric; if your fabric is not wide enough, cut them on the lengthwise grain before cutting the squares and 24½" strips.*

From the green plaid, cut on the lengthwise grain:

❀ 2 strips, 9½" x approximately 36"

❀ 2 strips, 9½" x approximately 68"

From the purple 1930s print, cut:

❀ 6 strips, 2" x 42"

Assembling the Quilt

1. Choose your favorite appliqué method and make templates for the flowers and leaves by tracing the patterns on pages 86–88. Refer to "Appliqué" on page 13 for details as needed. Cut out the number of each shape indicated on the patterns.

2. Make ¼"-wide bias stems from the red plaid bias strips. Refer to "Making Bias Vines" on page 19. Using the photo and the placement guides on pages 87 and 88, position the vines on the white center strips and pin. Appliqué in position.

3. Appliqué the leaves in position and then the flowers.

4. Sew the yellow quarter-square triangles to the ends of each strip. Press the seams toward the yellow triangles.

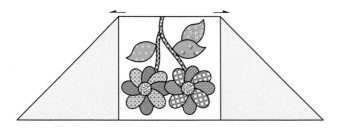

5. Sew the rows together. Press the seams in one direction.

6. Sew yellow half-square triangles to each of the four corners.

7. To add the top and bottom green plaid border, measure across the center of your quilt. Cut the 9½" x 36" strips to this measurement. Sew the strips to the top and bottom of the quilt. Press the seams toward the green plaid. To add the side borders, measure lengthwise through the center of your quilt. Cut the 9½" x 68" strips to this measurement. Sew the strips to the sides of the quilt. Press. Make ¼"-wide bias stems from the ½"-wide red plaid bias strips. Referring to the vine placement guide below, position and pin the vines on the green plaid borders. Appliqué in place.

8. Using the photo on page 82 as a guide, randomly place and appliqué the leaves to the border.

9. Position and appliqué all the flowers.

PLAID PIZZAZZ

Plaid and check fabrics add punch and visual dimension to your quilt. When purchasing these fabrics, purchase extra fabric so that you are able to match the patterns as you piece the quilt.

Woven plaids (the fabric looks the same on the front as it does on the back) are easier to match, as the colored threads make up the warp and weft of the fabric.

If a plaid or checked fabric is printed (the design is only on the right side of the fabric), you may experience some difficulty matching the plaid. Often, the design is not printed exactly on the straight grain of the fabric. Such was the case with the checked fabric that I used in the appliqué border in "Dance of the Flowers." That fabric was so charming, though, I couldn't resist it. It had the wonderful texture, feel, and look of old 1930s flour sacks, so I was willing to ignore the slight irregularity in the printing and not worry about the pattern matching exactly. I think the "imperfection" adds charm to the quilt and goes along with the 1930s theme.

Finishing the Quilt

Refer to "Quilting and Finishing" on page 29 for more details if needed.

1. Mark a quilting design on the quilt top if desired. See the quilting suggestion below.

2. Layer the quilt top with batting and backing; baste.

3. Quilt by hand or machine.

4. Bind the edges of the quilt.

5. Add a label to the back of your quilt.

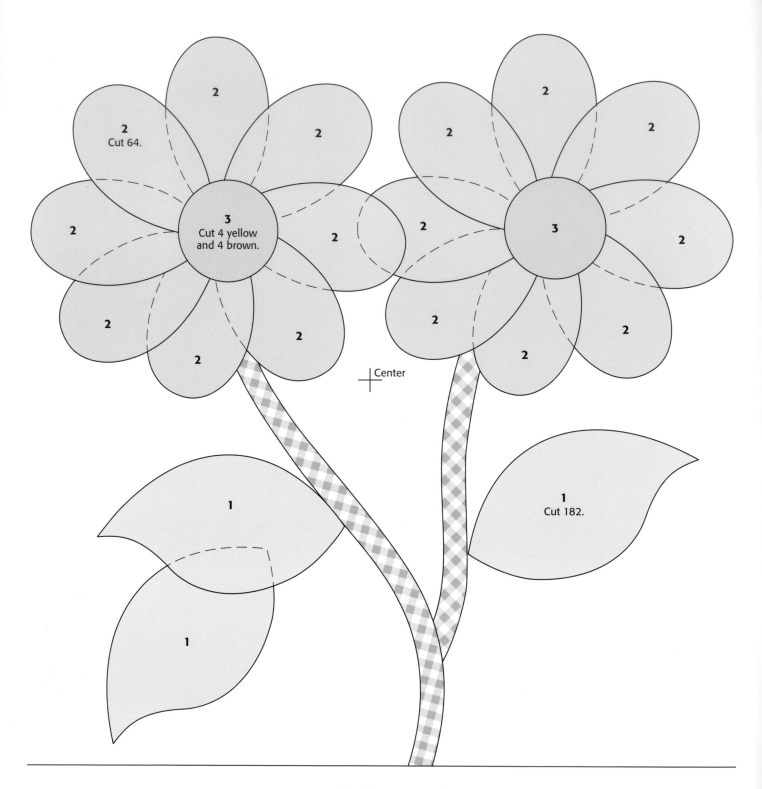

**Appliqué Patterns and
Placement Guide**

Strips 1 and 6

Strip 2
Placement Guide

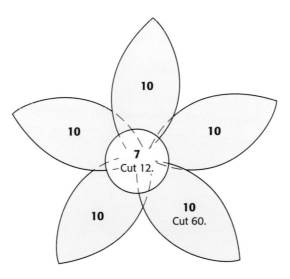

Strip 3
Placement Guide

**Appliqué Patterns and
Placement Guides**

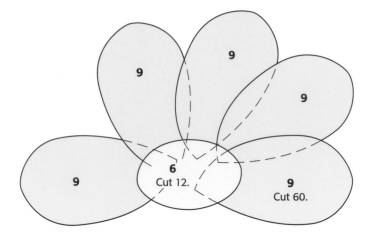

Strip 4
Placement Guide

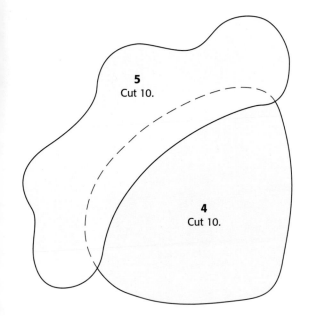

Strip 5
Placement Guide

**Appliqué Patterns and
Placement Guides**

Promises:
A Garden Wedding

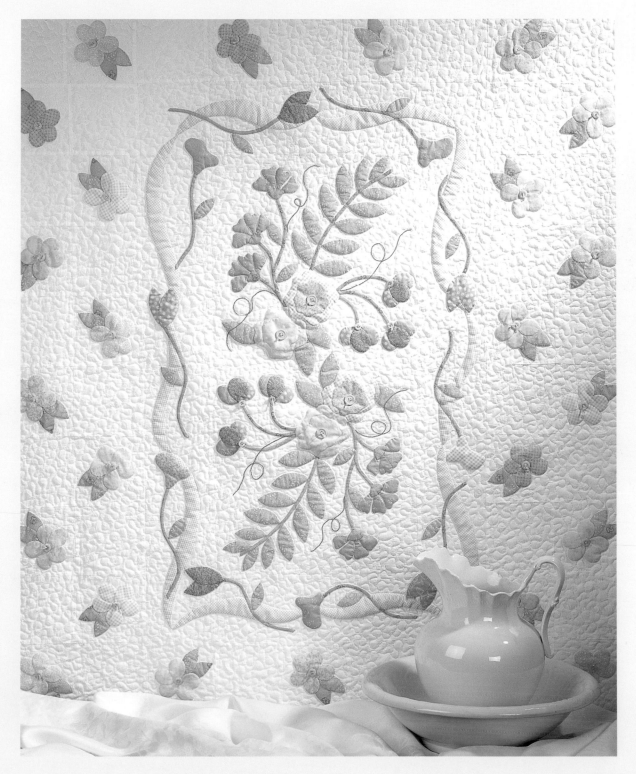

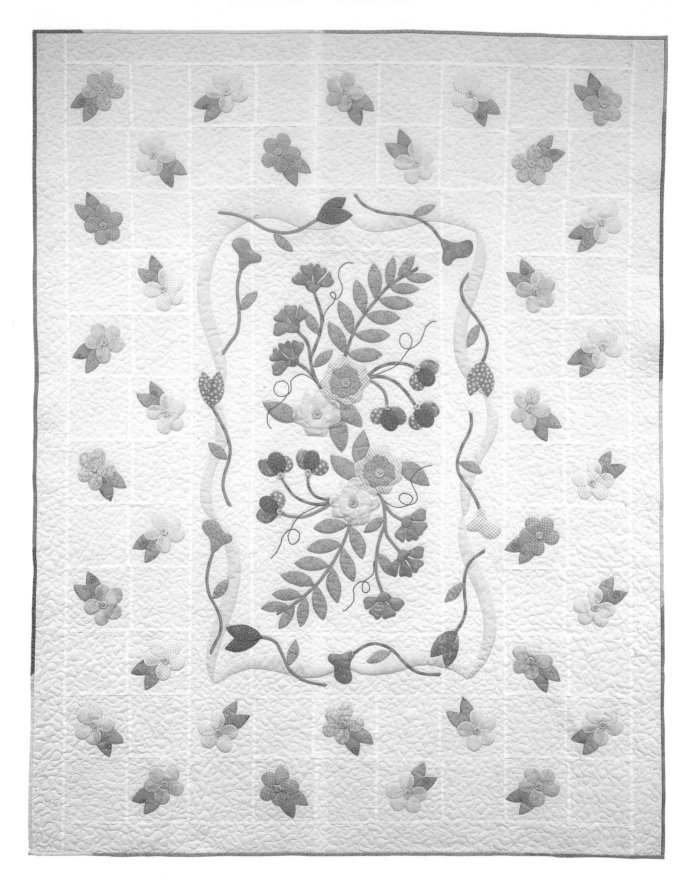

The white-on-white fabric in this quilt is a wonderful Japanese cotton fabric with a white raised embroidery thread running through it. When I saw it, I immediately pictured a beautiful garden wedding. I used hand appliqué and a large floral design in the center to give it a clean, elegant look in the soft colors that I love.

We've only just begun to live,
White lace and promises
A kiss for luck and we're on our way.
—Paul Williams and Roger Nichols

Quilt size: 50" x 65"

Materials

Yardage is based on 42"-wide fabric.

* 4 yds. of white-on-white print for block background and border 2
* ½ yd. of yellow plaid for ribbon appliqué on border 1
* ½ yd. of green print 1 for leaves and bias stems
* ¼ yd. of green print 2 for leaves
* ¼ yd. *each* of 3 lavender prints for flowers and binding
* ¼ yd. *each* of 6 pink prints for flowers and binding
* ¼ yd. *each* of 6 yellow prints for flowers and binding

* ¼ yd. *each* of 2 blue prints for flowers and binding
* 3½ yds. of fabric for backing
* 60" x 75" piece of batting
* Green 6-strand embroidery floss for tendrils
* 4 yellow buttons, ¾" diameter, for flower centers
* 6 yellow buttons, ⅜" diameter, for flower centers
* 34 yellow buttons, ½" diameter, for flower centers

Cutting

All measurements include ¼" seam allowances.

From green print 1, cut:

* ½"-wide bias strips to total approximately 210"

From the white-on-white print, cut on the lengthwise grain:

* 1 rectangle, 15½" x 30½"
* 68 squares, 5½" x 5½"
* 2 strips, 5½" x 15½"
* 2 strips, 5½" x 40½"
* 2 strips, 3" x approximately 47"
* 2 strips, 3" x approximately 67"

Assembling the Quilt

1. Choose your favorite appliqué method and make appliqué templates for ribbons, flowers, and leaves by tracing the required shapes from the templates on pages 94–96. Refer to "Appliqué" on page 13 for details as needed. Cut out the number of each shape as indicated on the patterns and refer to the appliqué cutting key on page 93 for specific details.

2. Make ¼"-wide bias stems from the green print 1 bias strips. Refer to "Making Bias Vines" on page 19. Using the photo on page 90 and the placement guide on page 94, position and pin the vines on the white-on-white print rectangles. Appliqué in place.

3. Appliqué all the leaves and then the flowers.

4. Using the stem stitch, embroider the tendrils. Refer to "Embroidery Stitches" on page 21.

5. Sew the white-on-white print 5½" x 15½" strips to the top and bottom of the center rectangle. Press the seams toward the border strips. Sew the white-on-white print 5½" x 40½" strips to the sides of the quilt. Press.

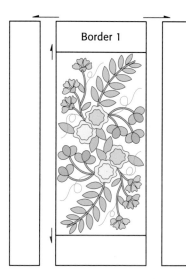

Border 1

6. Using the placement guide on page 95, position the ribbon pieces on the outer rectangles. Stitch in position using your chosen method of appliqué.

7. From the ½"-wide green bias strips, make ¼"-wide bias stems. Using the placement guide on page 95, position the stems and pin. Appliqué the stems in place.

8. Appliqué all the leaves and then the flowers.

9. Using the pattern on page 96 as a guide, appliqué the leaves on 34 of the 5½" x 5½" white-on-white blocks. Appliqué 17 blocks with yellow flowers and 17 blocks with pink flowers.

10. Sew the blocks together, pressing the seams in alternating directions and then sew to the center unit. Press the seams toward the edges of the quilt.

11. To add border 2 to the top and bottom, measure the width of the quilt through the center and cut the 3" x 47" strips to this measurement. Sew to the top and bottom of the quilt and press the seams toward the border strips. Measure the length of the quilt through the center; cut the 3" x 67" border strips to this length and sew to the sides. Press.

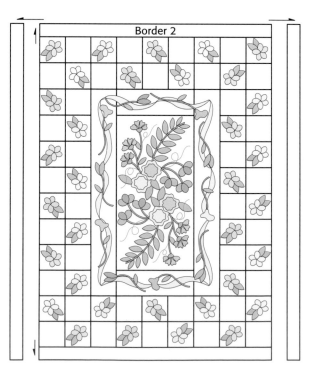

Border 2

Finishing the Quilt

Refer to "Quilting and Finishing" on page 29 for more details if needed.

1. Mark the quilting design on the quilt top if desired. The quilt shown was outline quilted around the appliqués and stipple quilted in remaining areas.

2. Layer the quilt top with batting and backing; baste.

3. Quilt by hand or machine.

4. Make a pieced binding by cutting 2"-wide binding strips from several of the prints. Vary the lengths as shown in the photo. Bind the edges of the quilt.

5. Add a label to the back of your quilt.

6. Add the buttons to the flower centers. Refer to "Embellishments" on page 20. Sew the ¾" buttons to the pink and yellow flowers in the center, the ⅜" buttons to the purple flowers in the center panel, and the ½" buttons to the outer pink and yellow flowers.

Appliqué Cutting Key

From green print 1, cut:
* 6 of template 12
* 34 of template 2

From green print 2, cut:
* 6 of template 1
* 50 of template 2
* 4 of template 3
* 4 of template 4
* 14 of template 5

From the yellow plaid, cut:
* 2 of template 14 and 2 of template 14 reversed
* 2 of template 15 and 2 of template 15 reversed
* 2 of template 16

From various lavender prints, cut:
* 18 of template 13
* 10 of template 2

From various pink prints, cut:
* 2 of template 6
* 2 of template 7
* 2 of template 17
* 85 of template 18

From various blue prints, cut:
* 6 of template 8
* 6 of template 9
* 6 of template 10
* 6 of template 11
* 3 of template 17

From various yellow prints, cut:
* 2 of template 6
* 2 of template 7
* 85 of template 18

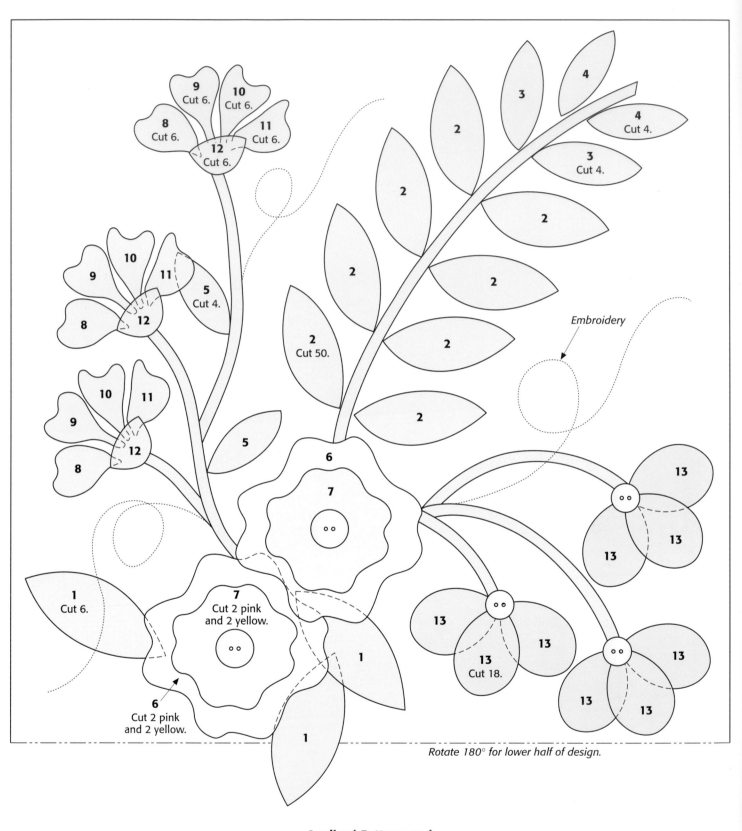

**Appliqué Patterns and
Placement Guide**

Enlarge this pattern 200%.

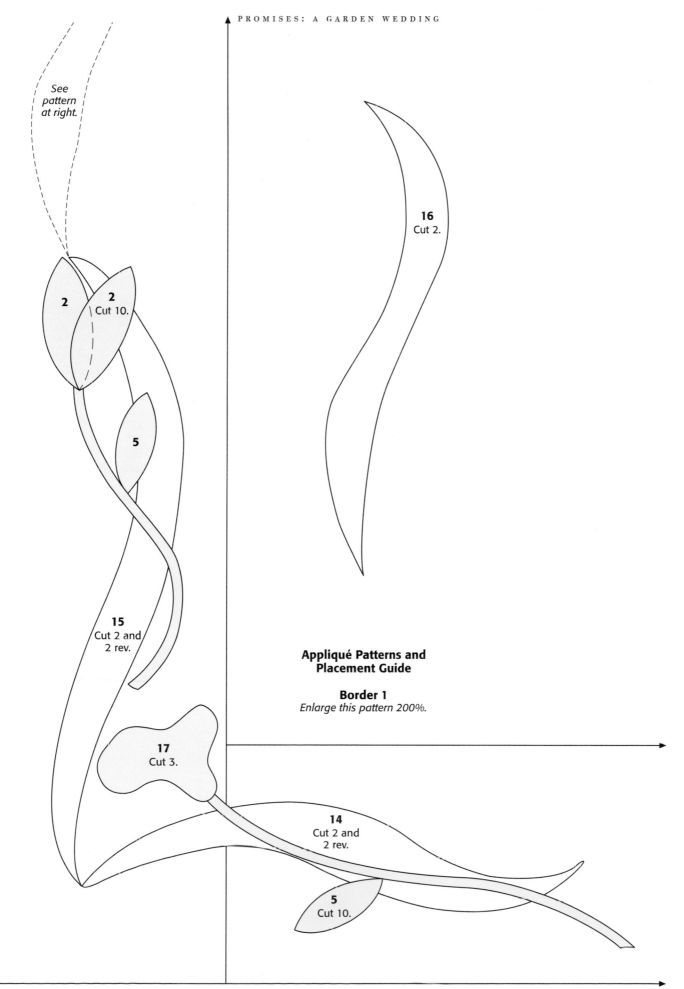

See pattern at right.

2

2
Cut 10.

5

16
Cut 2.

15
Cut 2 and
2 rev.

**Appliqué Patterns and
Placement Guide**

Border 1
Enlarge this pattern 200%.

17
Cut 3.

14
Cut 2 and
2 rev.

5
Cut 10.

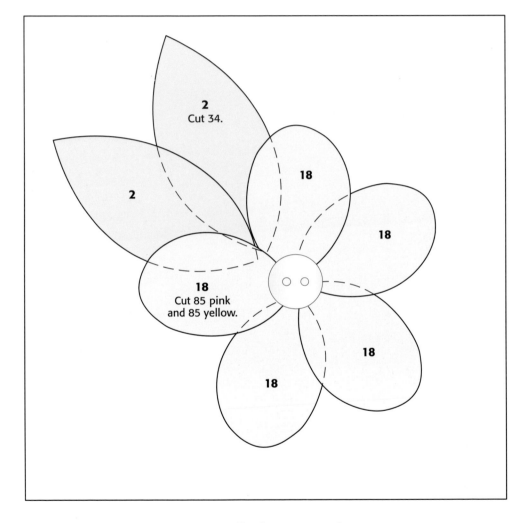

**Appliqué Patterns and
Placement Guide**

Scented So Sweetly

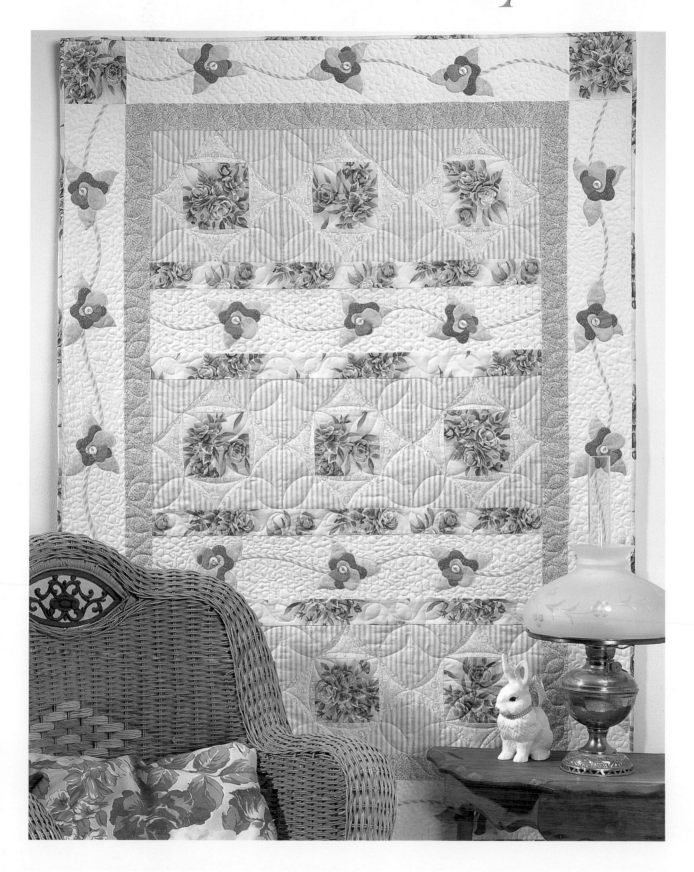

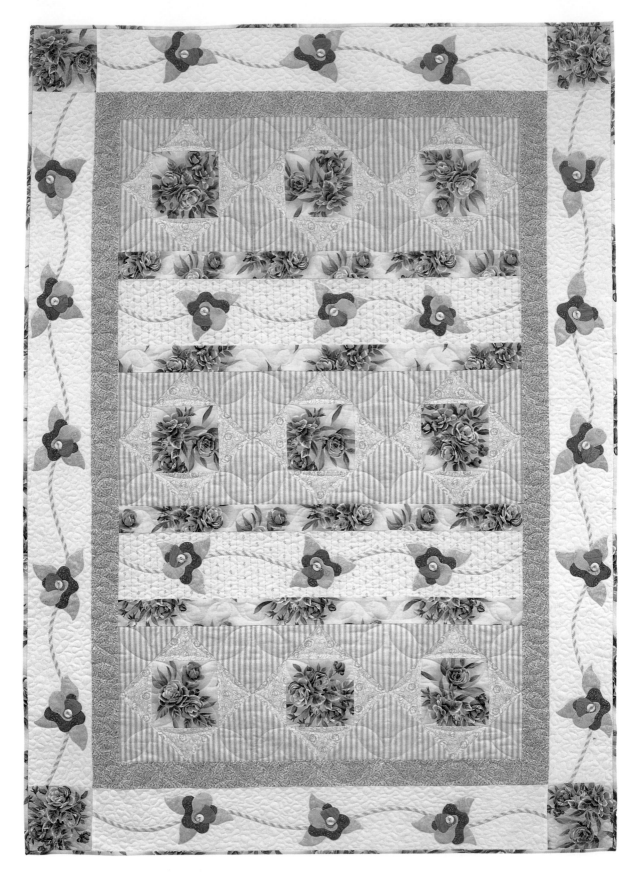

Here's another quilt that reflects more than a few of my favorite things: old-fashioned ticking fabric; a large floral print; floral appliqué; soft, bright colors; and buttons, of course! What could be more perfect?

In the soft evening glow
Gently they bloom
Caressing us all
With their sweet perfume

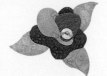

Quilt size: 44" x 62"

Materials

Yardage is based on 42"-wide fabric.

❀ 1¾ yds. of small-scale lavender print for border 1

❀ 1¾ yds. of muslin for border 2

❀ 1½ yds. of large-scale floral print for center blocks, horizontal sashing strips, corner squares, and binding*

❀ 1⅛ yds. of green-and-beige ticking stripe for center blocks and bias vines

❀ ½ yd. of beige-and-green narrow stripe for center strips (background for appliqué)

❀ ⅜ yd. of medium-scale lavender print for center blocks

❀ ¼ yd. of green print 1 for leaves

❀ ¼ yd. of green print 2 for leaves

❀ ¼ yd. of purple print for flowers

❀ ¼ yd. of medium lavender print for flowers

❀ ¼ yd. of light lavender print for flowers

❀ 3 yds. of fabric for backing

❀ 54" x 72" piece of batting

❀ 22 beige buttons, ½" diameter, for flower centers

❀ Green 6-strand embroidery floss for flower centers

You may want to purchase extra fabric for centering the floral motifs if they are far apart on your fabric. You will need 13 floral motifs.

Cutting

All measurements include ¼" seam allowances.

From the medium-scale lavender print, cut:

❀ 2 strips, 4⅜" x 42"; cut the strips into 18 squares, 4⅜" x 4⅜"; cut into 36 half-square triangles

From the large-scale floral print, cut:

❀ 13 squares, 5½" x 5½"

❀ 4 strips, 2½" x approximately 32"

❀ 6 strips, 2" x 42"

From the green-and-beige ticking stripe, cut:

✿ 3 strips, 5⅞" x 42"; cut the strips into 18 squares, 5⅞" x 5⅞"; cut into 36 half-square triangles.

✿ ½"-wide bias strips to total 310"

From the beige-and-green narrow stripe, cut:

✿ 2 strips, 5½" x approximately 32"

From the small-scale lavender print, cut on the lengthwise grain:

✿ 2 strips, 2½" x approximately 32"

✿ 2 strips, 2½" x approximately 54"

From the muslin, cut on the lengthwise grain:

✿ 2 strips, 5½" x approximately 36"

✿ 2 strips, 5½" x approximately 54"

Assembling the Quilt

1. Sew the lavender triangles to nine of the 5½" floral squares. Press.

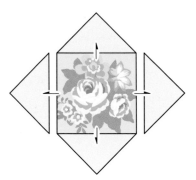

2. Sew the ticking triangles to the units from step 1. Press toward the ticking. Make nine blocks.

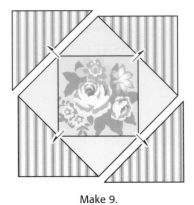

Make 9.

3. Sew the blocks together to make three rows of three blocks each. Press the seams in one direction.

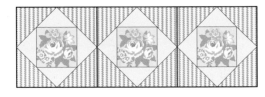

Make 3 rows.

4. Choose your favorite appliqué method and make templates for the flowers and leaves by tracing template patterns 1–4 on page 102. Refer to "Appliqué" on page 13 for details as needed. Cut out the number of each shape as indicated on the patterns.

5. Make ¼-wide bias vines from the ticking bias strips. Refer to "Making Bias Vines" on page 19. Using the center layout as a guide, appliqué the vines to the two beige-and-green narrow-stripe strips.

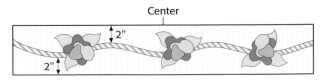

Center

2"

2"

Center Layout

6. Randomly position and appliqué the leaves and petals for three flowers along the bias vine. Complete the two center strips.

7. Measure across the row of pieced blocks to determine the true measurement of your center row. Trim floral sashing strips and center appliqué strips to this measurement. Sew the center rows of the quilt together, placing the floral sashing strips between each row.

8. For border 1, cut the 2½" x 32" lavender strips to the measurement from step 7, and sew the strips to the top and bottom of the center unit. Press the seams toward the lavender strips.

9. To add the side borders, measure lengthwise through the center of your quilt. Cut the 2½" x 54" lavender strips to this measurement. Sew the strips to the sides of the center background unit. Press.

10. For border 2, measure across the center of your quilt. Cut the 5½" x 36" muslin strips to this measurement for the top and bottom borders. Measure lengthwise through the center of the quilt and cut the 5½" x 54" strips to this measurement for the sides.

11. For the top and bottom strips of border 2, appliqué the bias vines, using the center layout as a guide. Appliqué the three sets of leaves and flowers randomly along the vine.

12. For the side strips of border 2, appliqué the bias vines, using the side border of the quilt layout at left as a guide. Appliqué the five sets of leaves and flowers randomly along the vine.

13. Sew a 5½" floral square to each end of the side border strips. Press the seams toward the corner blocks.

14. Sew the top and bottom border 2 strips to the center unit.

15. Sew the side border 2 strips to the center unit.

Finishing the Quilt

Refer to "Quilting and Finishing" on page 29 for more details if needed.

1. Mark a quilting design on the quilt top if desired. See the quilting suggestion below.

2. Layer the quilt top with batting and backing; baste.

3. Quilt by hand or machine.

4. Sew the buttons to the flower centers, referring to "Embellishments" on page 20 for details.

5. Bind the edges of the quilt.

6. Add a label to the back of your quilt.

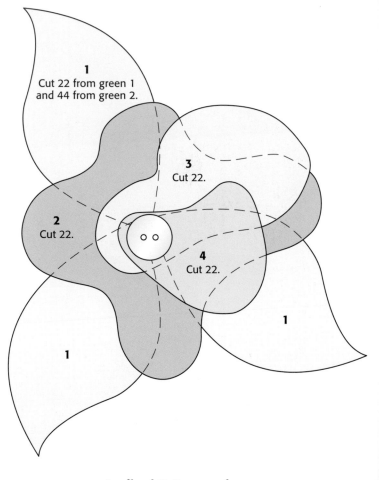

Appliqué Patterns and Placement Guide

He Loves Me . . .

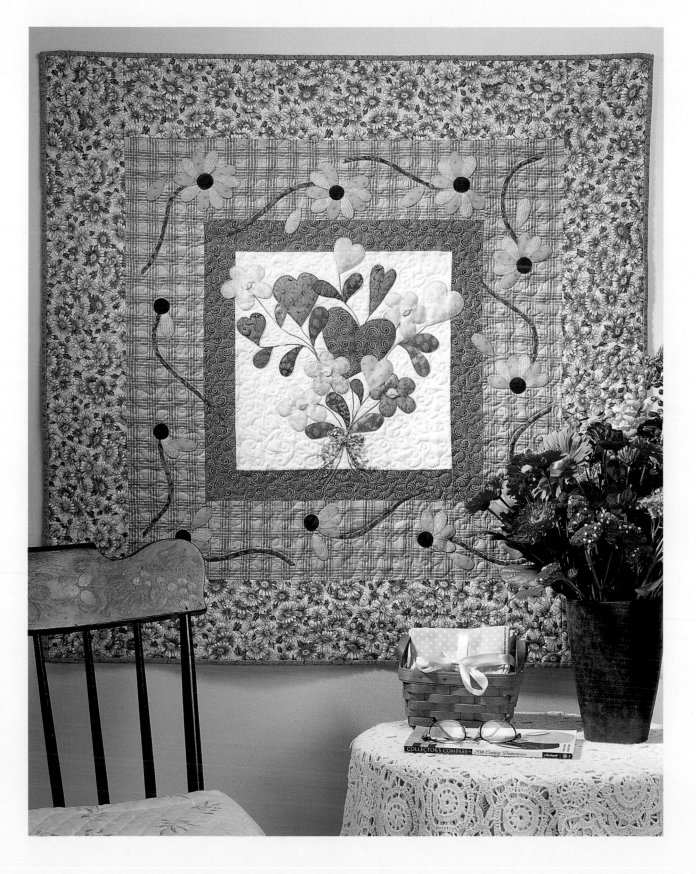

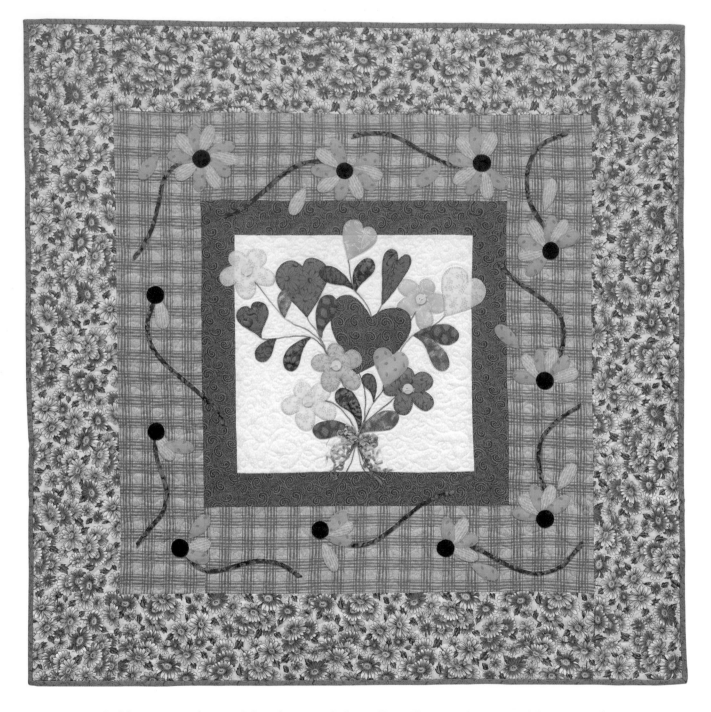

*Daisies are everywhere, and they always remind me of love. The center bouquet and daisies were done
in fusible appliqué. I've combined florals and plaids—always a winning pair. In the plaid daisy border,
one by one, the petals drop off. He loves me, he loves me not . . . a silly game, but what fun to play!*

He loves me, he loves me not

He loves me, he loves me not

He loves me . . .

Quilt size: 38" x 38"

Materials

Yardage is based on 42"-wide fabric.

- ¾ yd. of green plaid for border 2
- ¾ yd. of daisy print for border 3
- ½ yd. of white-on-white print for center square
- ⅜ yd. of purple print 1 for border 1 and large center heart
- ¼ yd. of green print 1 for bias stems and leaves
- Scraps or fat quarters of the following prints for flowers, flower centers, hearts, and leaves: 2 green, 1 lavender, 3 blue, 3 yellow, 1 brown

- 1½ yds. of fabric for backing
- ⅜ yd. of purple print 2 for binding
- 48" x 48" piece of batting
- Green and yellow 6-strand embroidery floss for stems and flower centers
- 5 yellow buttons, ½" diameter, for flower centers
- Silk ribbon and beads for embellishment

Cutting

All measurements include ¼" seam allowances.

From the white-on-white print, cut:
- 1 square, 14½" x 14½"

From purple print 1, cut:
- 2 strips, 2½" x 14½"
- 2 strips, 2½" x 18½"

From the green plaid, cut:
- 2 strips, 5½" x 18¼"
- 2 strips, 5½" x 28½"

From green print 1, cut:
- ½"-wide bias strips to total 120"

From the daisy print, cut:
- 2 strips, 5½" x 28½"
- 2 strips, 5½" x 38½"

From purple print 2, cut:
- 4 strips, 2" x 42"

Assembling the Quilt

1. Sew the purple 2½" x 14½" strips to the top and bottom of the 14½" center square. Press the seams toward the purple strips. Sew the 2½" x 18½" purple strips to the sides of the center square. Press.

2. Choose your favorite appliqué method and make templates for the hearts, flowers, and leaves by enlarging and tracing the template patterns on page 108 and and by tracing those on page 109. Refer to "Appliqué" on page 13 for details as needed. Cut out the number of each shape indicated on the patterns and in the appliqué cutting key on page 107.

3. Appliqué the flowers, leaves, and hearts to the center section.

4. Use a stem stitch for the flower stems. Refer to "Embroidery Stitches" on page 21.

5. Sew the 5½" x 18½" green plaid border strips to the top and bottom of the quilt center. Press toward the green plaid. Sew the 5½" x 28½" green plaid border strips to the sides. Press.

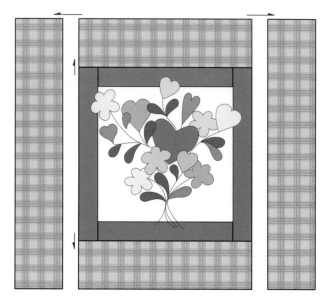

6. From the ½"-wide bias strips, make ¼"-wide bias stems, referring to "Making Bias Vines" on page 19. Cut the bias stem into 11 pieces, each 10" long. Pin in position on the border strips, following the quilt assembly diagram on page 107. Appliqué the stems in place.

7. Appliqué the flower petals and flower centers. Begin in the upper left-hand corner, and appliqué one fewer petal to each flower as you go around the border in a clockwise direction. Refer to the quilt photo on page 104 for placement of the discarded petals.

8. Sew the 5½" x 28½" daisy-print border strips to the top and bottom of the quilt. Press toward the daisy print. Sew the 5½" x 38½" border strips to the sides. Press.

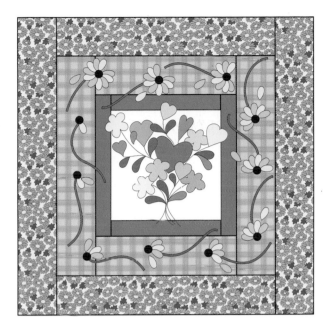

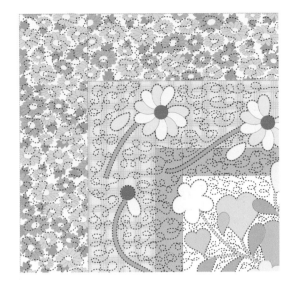

Finishing the Quilt

Refer to "Quilting and Finishing" on page 29 for more details if needed.

1. Mark a quilting design on the quilt top if desired. See the quilting suggestion above right.

2. Layer the quilt top with batting and backing; baste.

3. Quilt by hand or machine.

4. Bind the edges of the quilt.

5. Add a label to the back of your quilt.

6. Sew the buttons to the flowers in the center square. Add a silk-ribbon bow and beads to the base of the bouquet. Refer to "Beaded Ribbons" on page 23.

Appliqué Cutting Key

From the green prints, cut:
* 1 of template 8
* 1 of template 9
* 2 of template 10
* 2 of template 11
* 2 of template 12
* 1 of template 13
* 1 of template 14
* 1 of template 15
* 1 of template 16

From the purple print, cut:
* 1 of template 2

From the lavender print, cut:
* 1 of template 1
* 1 of template 5
* 1 of template 6
* 1 of template 7

From the blue prints, cut:
* 2 of template 1
* 1 of template 3

From the yellow prints, cut:
* 2 of template 1
* 1 of template 3
* 1 of template 4
* 66 of template 17

From the brown print, cut:
* 11 of template 18

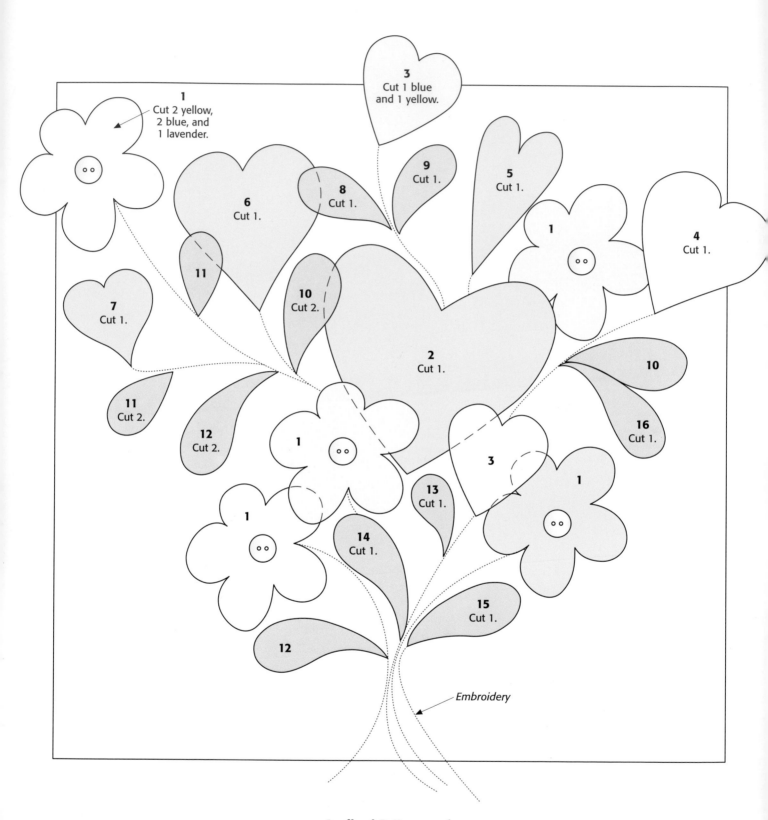

1
Cut 2 yellow,
2 blue, and
1 lavender.

3
Cut 1 blue
and 1 yellow.

9
Cut 1.

5
Cut 1.

6
Cut 1.

8
Cut 1.

4
Cut 1.

1

11

10
Cut 2.

7
Cut 1.

2
Cut 1.

10

11
Cut 2.

16
Cut 1.

12
Cut 2.

1

3

1

13
Cut 1.

1

14
Cut 1.

15
Cut 1.

12

Embroidery

**Appliqué Patterns and
Placement Guide**

Center
Enlarge this pattern 200%.

· 108 ·

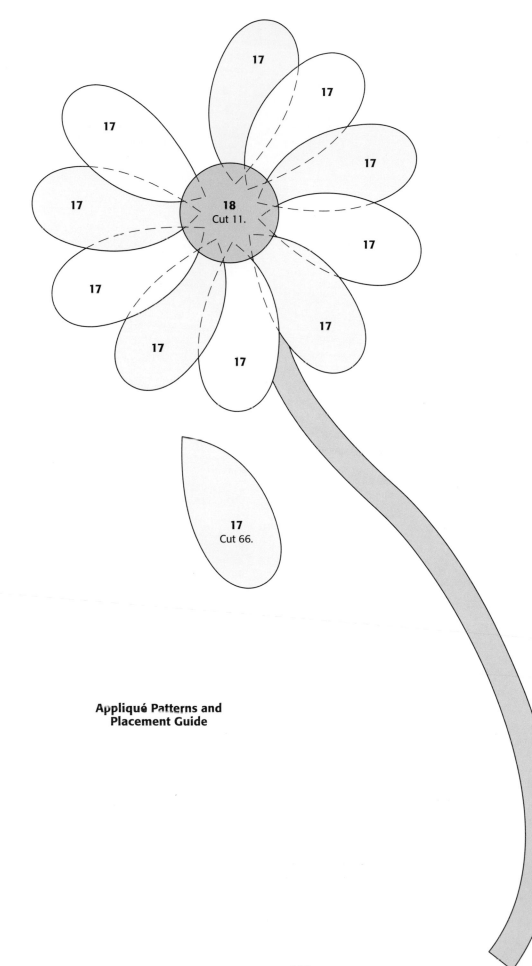

17

17

17

17

17

18
Cut 11.

17

17

17

17

17

17

17
Cut 66.

**Appliqué Patterns and
Placement Guide**

Gatherings

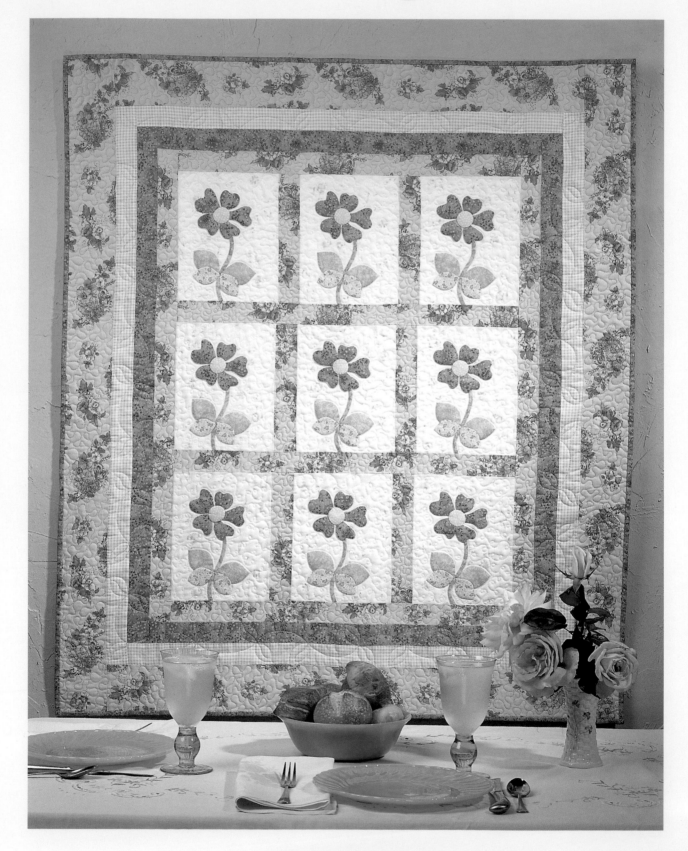

Up in the meadow
At dawn's early light
They're soft and pink
And kissed by the light

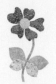

Quilt size: 40" x 46"

Materials

Yardage is based on 42"-wide fabric.

- 1½ yds. of green floral print for sashing, border 1, and border 4
- 1 yd. of dark pink print for flowers, border 2, and binding*
- ¾ yd. of off-white print for block background
- ¼ yd. of pink plaid for border 3
- ¼ yd. of green print 1 for bias stems
- ¼ yd. *each* of green print 2 and green print 3 for leaves
- ⅛ yd. of pink polka dot for flower centers
- 3 yds. of fabric for backing
- 50" x 56" piece of batting

Cutting

All measurements include ¼" seam allowances.

From green print 1, cut:
- ½"-wide bias strips to total 60"

From the off-white print, cut:
- 9 rectangles, 7½" x 9½"

From the green floral print, cut on the lengthwise grain:
- 6 strips, 2" x 9½"
- 4 strips, 2" x 24½"
- 2 strips, 2" x 33½"
- 2 strips, 4" x 33½"
- 2 strips, 4" x 46½"

From the dark pink print, cut:
- 2 strips, 2" x 27½"
- 2 strips, 2" x 36½"
- 5 strips, 2" x 42"

From the pink plaid, cut:
- 2 strips, 2" x 30½"
- 2 strips, 2" x 39½"

Hand-dyed fabrics are wonderful for the flowers in this quilt. Make the flowers in each block similar in color, or make each one different.

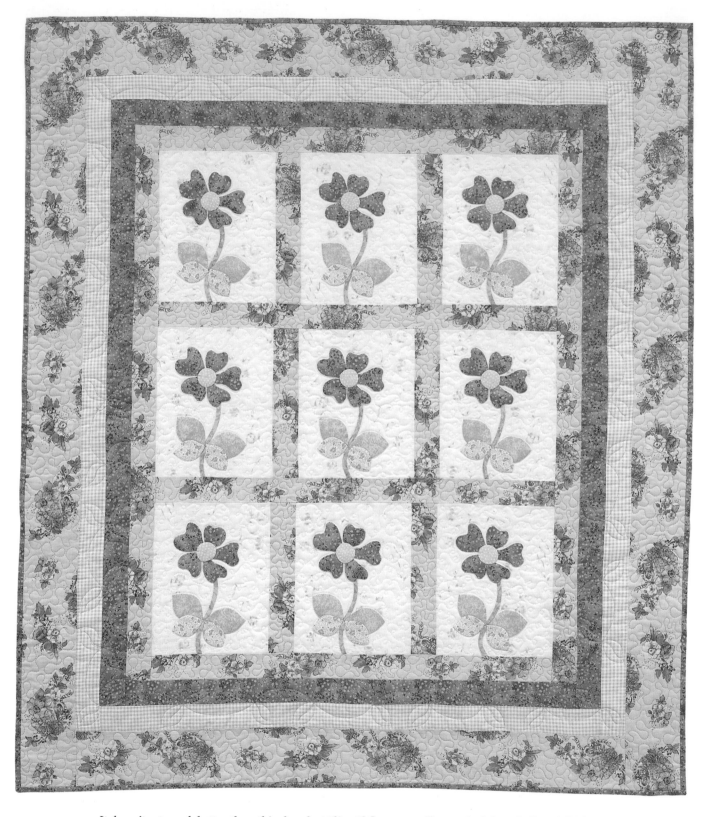

It doesn't get much better than this: hand-appliquéd flowers, mellow and pink and all in full bloom.
They appear to be swaying in the summer breeze, ready to cheer you up at a moment's notice.

Assembling the Quilt

1. Choose your favorite appliqué method and make appliqué templates for the flowers and leaves by tracing the patterns on page 114. Refer to "Appliqué" on page 13 for details as needed. Cut out the number of each shape indicated on the patterns.

2. Make ¼"-wide bias stems from the ½"-wide green 1 bias strips. You will need nine stems approximately 6½" long. Refer to "Making Bias Vines" on page 19.

3. Using the placement guide on page 114, position bias stems on nine of the background blocks and pin. Appliqué in place.

4. Position and appliqué the flowers and leaves on each block.

5. Sew the nine center blocks into three rows of three blocks each, placing the 2" x 9½" green floral sashing strips between the blocks.

Make 3.

6. Sew the 2" x 24½" green floral sashing strips between the rows and to the top and bottom. Press the seams toward the green floral strips. Add the 2" x 33½" strips to the sides. Press.

7. Add borders 2, 3, and 4, pressing toward the border just added. Refer to the quilt assembly diagram below.

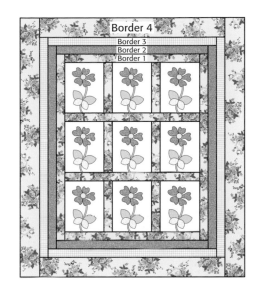

Finishing the Quilt

Refer to "Quilting and Finishing" on page 29 for more details if needed.

1. Mark a quilting design on the quilt top if desired. See the quilting suggestion below.

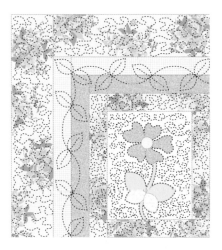

2. Layer the quilt top with batting and backing; baste.

3. Quilt by hand or machine and then bind the edges of the quilt with the dark pink strips. Add a label to the back of your quilt.

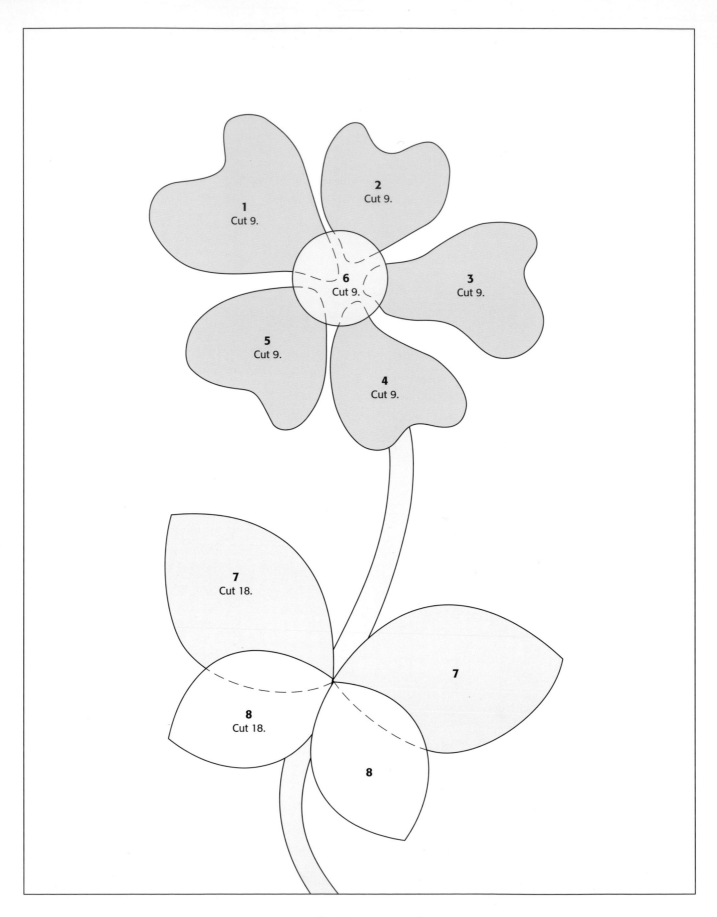

**Appliqué Patterns and
Placement Guide**

Love Notes

*Capture words of love on this special quilt. The crazy-patch blocks and embellishments give this quilt
a traditional, but enchanting, Victorian look. Embellish the blocks as much or as little as you like.
The charm is in the variety of embellishments that you use.*

Write me a line

A sonnet or two

Tell me you love me

As I love you

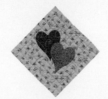

Quilt size: 36" x 36"

Materials

Yardage is based on 42"-wide fabric.

- ¾ yd. of off-white print for border 2 and border 4
- ⅝ yd. of muslin for pieced-block foundation
- ½ yd. of beige print for center square and pieced blocks
- ½ yd. of gold polka dot for center triangles and pieced blocks
- ½ yd. of medium purple print for heart, pieced blocks, and binding
- ¼ yd. of off-white fabric for border 1 and pieced blocks

- ¼ yd. of dark purple print for heart and pieced blocks
- ¼ yd. *each* of 2 green prints for pieced blocks
- 1½ yds. of fabric for backing
- 46" x 46" piece of batting
- Miscellaneous threads, embroidery floss, sequins, beads, buttons, trims, silk ribbon, etc. for embellishments
- Permanent, fine-point fabric pen

Cutting

All measurements include ¼" seam allowances.

From the beige print, cut:
- 1 square, 10½" x 10½"

From the gold polka dot, cut:
- 2 squares, 8" x 8"; cut the squares into 4 half-square triangles

From the off-white fabric, cut:
- 2 strips, 1½" x 14½"
- 2 strips, 1½" x 16½"

From the off-white print, cut:
- 2 strips, 2½" x 16½"
- 2 strips, 2½" x 20½"
- 2 strips, 3½" x 30½"
- 2 strips, 3½" x 36½"

From the medium purple print, cut:

❀ 4 strips, 2" x 42"

From the muslin, cut:

❀ 20 squares, 5½" x 5½"

Assembling the Quilt

1. Choose your favorite appliqué method and make appliqué templates for the hearts by tracing the pattern on page 121. Refer to "Appliqué" on page 13 for details as needed.

2. Cut one heart from each purple fabric and appliqué them to the center of the 10½" beige square. See page 121 and the photo on page 116 for placement and note that the center square is set on point.

3. Using two strands of embroidery floss and a stem stitch, stitch the trailing vines. Refer to "Embroidery Stitches" on page 21. Sew sequins, beads, or small buttons to the end of each trailing vine if desired.

4. Sew the four polka dot triangles to the center square to make the center unit. Press toward the triangles.

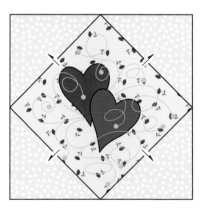

5. To add border 1, sew the 1½" x 14½" off-white strips to the top and bottom. Press the seams toward border 1. Sew the 1½" x 16½" off-white strips to the sides of the quilt. Press.

6. Using a fine-point, waterproof fabric pen, write your prose or poetry on all four sides of border 1. Center your writing within the 1" border. See "Poetic Verses" on page 120 for suggestions and inspiration.

FRIENDLY ADVICE

Use the seam allowance from border 1 as a guide for keeping your writing straight. I place my quilt top directly on the ironing board and use that as my writing surface. Some quilters like to iron a strip of freezer paper to the wrong side of the fabric to help stabilize the fabric for writing. ❧

7. Sew the 2½" x 16½" off-white print border strips to the top and bottom. Press toward the off-white strips. Sew the 2½" x 20½" strips to the sides. Press.

Crazy-Patch Blocks

Border 3 consists of 20 crazy-patchwork blocks that finish at 5" square. Use scraps of all your fabrics to piece these blocks. This method uses 5½" squares of muslin as the foundation on which you will sew the other patches of fabric. Make a template for the

first patch, using the pattern on page 121. The size of this center patch will give you large-enough pieces that are easy to embellish.

1. Begin each block with patch 1. Trace around the patch 1 template and cut the patch from any of your fabric scraps. Place the patch in the center of your muslin square, right side up.

2. For patch 2, choose a scrap of fabric and lay it right side down on top of patch 1, lining up the raw edges along one side of patch 1. Be sure that patch 2 is large enough to extend to the edge of the muslin base after it is stitched. Stitch ¼" from the raw edges.

3. Turn patch 2, right side up, on the muslin base and press. Use scissors to trim patch 2; use the edges of patch 1 to make a straight-line cut on both sides.

4. Working counterclockwise, choose a scrap of fabric for patch 3 that is large enough to cover the edge created by patches 1 and 2. Again line up the raw edges and stitch ¼" from the raw edges. Flip patch 3 right side up and press. Trim as before.

5. Continue to work around the block, adding a total of five patches around patch 1.

6. When you have covered the muslin base, trim the patches even with the edges of the muslin square.

Make 20.

7. Using an assortment of beads, buttons, trims, silk ribbon, threads, and charms, embellish each block. Refer to "Embellishments" on page 20.

Borders

1. Sew the crazy-patch blocks together in two rows of four blocks each for the top and bottom borders. Sew two rows of six blocks each for the side borders. Sew the borders to the center unit, adding the top and bottom first, and then the sides.

2. Sew the 3½" x 30½" off-white strips to the top and bottom of the quilt top. Press toward the off-white strips. Sew the 3½" x 36½" strips to the sides. Press.

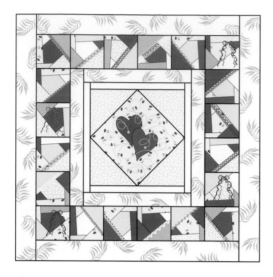

Finishing the Quilt

Refer to "Quilting and Finishing" on page 29 for more details if needed. When deciding how to quilt your quilt, keep in mind that it is more difficult to hand quilt through the crazy-patch blocks since the muslin foundation adds an extra layer of fabric.

1. Mark a quilting design on the quilt top if desired. See the quilting suggestion below.

2. Layer the quilt top with batting and backing; baste.

3. Quilt by hand or machine.

4. Bind the edges of the quilt.

5. Add a label to the back of your quilt.

POETIC VERSES

Compose your own love notes, or choose your favorites from the following quotes that I used in my quilt. Read on, and maybe you'll feel inspired to write your own.

How do I love thee? Let me count the ways.
—ELIZABETH BARRETT BROWNING

Come live with me and be my love. . . .
—CHRISTOPHER MARLOWE

All my heart is yours.
—CHARLOTTE BRONTË

If ever two were one, then surely we.
—ANNE BRADSTREET

I love thee to the depth and breadth and height my soul can reach . . .
—ELIZABETH BARRETT BROWNING

In loving you, I love the best the world has to give. —ROBERT SCHUMANN

Places that are empty of you are empty of all life. —DANTE GABRIEL ROSSETTI

I carry you in my heart.
—CYNTHIA TOMASZEWSKI

I swear I will love thee with my whole heart.
—THOMAS CARLYLE

**Appliqué Patterns and
Placement Guide**

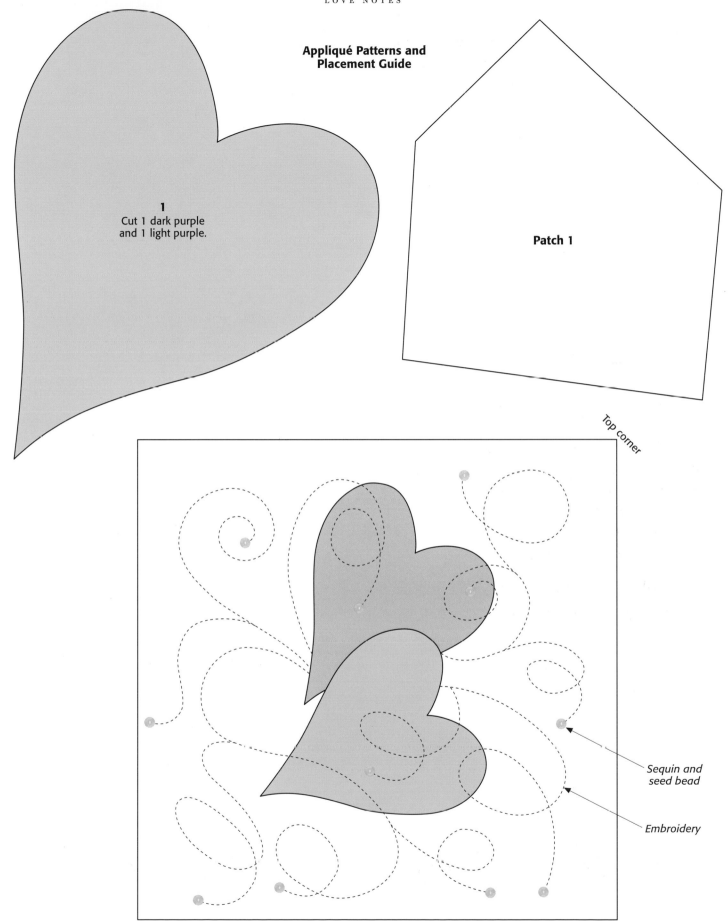

1
Cut 1 dark purple
and 1 light purple.

Patch 1

Top corner

*Sequin and
seed bead*

Embroidery

Appliqué and Embroidery Placement Guide

Heart to Heart

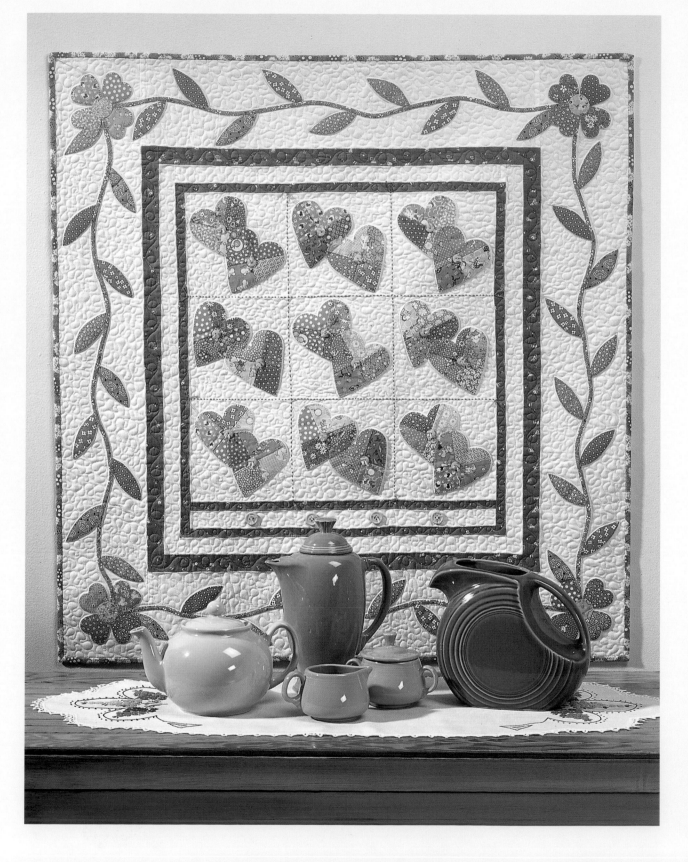

Tic tac two, I love you!

Quilt size: 33" x 34½"

Materials

Yardage is based on 42"-wide fabric.

- ❀ 1½ yds. of white fabric for background
- ❀ ¾ yd. of green print for vines and leaves
- ❀ ½ yd. of purple print 1 for borders 1 and 3
- ❀ Scraps of numerous 1930s reproduction prints for hearts and flowers*
- ❀ Scraps of 6 different green prints for leaves
- ❀ 1½ yds. of fabric for backing

- ❀ ⅜ yd. of purple print 2 for binding
- ❀ 43" x 45" piece of batting
- ❀ Green and yellow 6-strand embroidery floss
- ❀ 18 yellow buttons, ½" diameter, for heart centers
- ❀ 4 buttons, ¾" diameter, for border

**I used approximately 40 different prints. Precut variety packs of 4" or 10" squares are perfect for this project.*

Cutting

All measurements include ¼" seam allowances.

From the white fabric, cut:
- ❀ 1 square, 18½" x 18½"
- ❀ 1 strip, 1½" x 18½"
- ❀ 2 strips, 1½" x 19½"
- ❀ 2 strips, 1½" x 23"
- ❀ 2 strips, 5½" x 23½"
- ❀ 2 strips, 5½" x 35"

From various 1930s prints, cut:
- ❀ 72 squares, 2½" x 2½"

From purple print 1, cut:
- ❀ 3 strips, 1" x 18½"
- ❀ 2 strips, 1" x 21"
- ❀ 2 strips, 1½" x 21½"
- ❀ 2 strips, 1½" x 25"

From the green print, cut:
- ❀ ½"-wide bias strips to total 170"

From purple print 2, cut:
- ❀ 4 strips, 2" x 42"

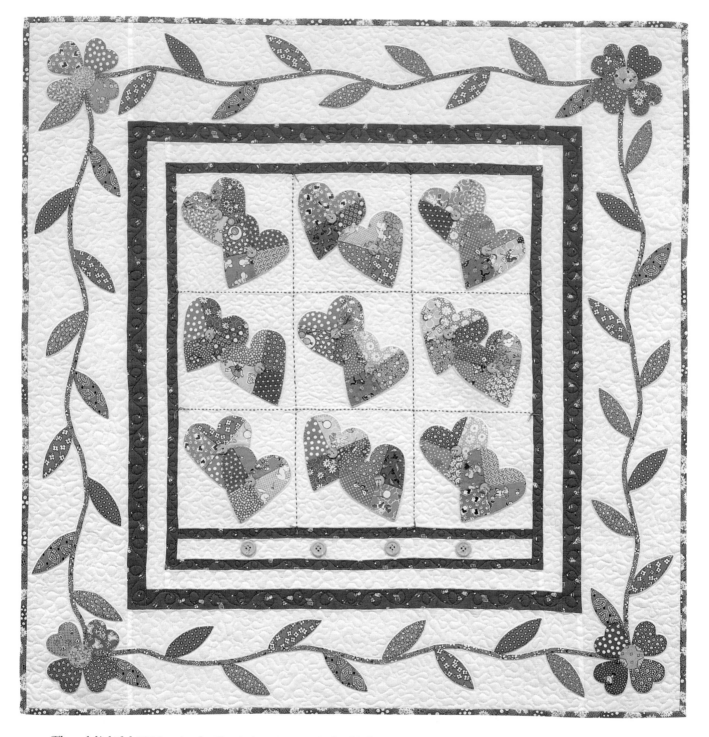

Those delightful 1930s reproduction prints star again in this happy-go-lucky quilt that fairly bubbles over with simple, heartfelt delight. The cheery design would work with just about any fabrics, from pastels and jewel tones to deep, rich country colors. Or, if you happen to have some scraps on hand, make it totally random and scrappy!

Assembling the Quilt

1. With a No. 2 pencil, very lightly divide and mark the 18½" background square into nine squares, 6" x 6".

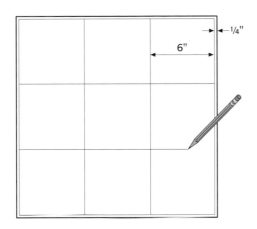

2. Sew together four 2½" squares of the reproduction fabrics to make a four-patch unit, 4½" x 4½". Make 18 units.

Make 18.

3. Choose your favorite appliqué method and make appliqué templates for the hearts, flowers, and leaves by tracing the patterns on page 127. Refer to "Appliqué" on page 13 for details as needed. Cut out the number of flowers and leaves indicated on the patterns.

4. Using the heart template, cut 18 hearts from the four-patch blocks. Appliqué two hearts in each of the nine squares of the background piece. Overlap the hearts as in the photo on page 124.

5. Sew a 1" x 18½" purple strip to the bottom of the 18½" background square. Then add one white 1½" x 18½" strip. Press the seams toward the purple strip.

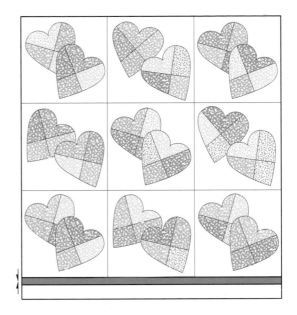

6. Sew 1" x 18½" purple strips to the top and bottom of the center unit. Press the seams toward the purple strips. Sew the two 1" x 21" purple strips to the sides. Press.

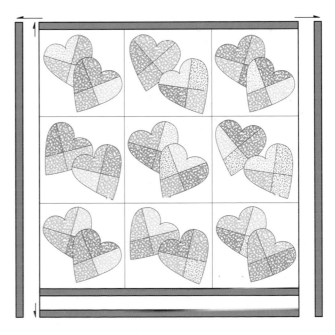

7. Sew the 1½" x 19½" white strips to the top and bottom. Add the 1½" x 23" strips to the sides.

8. Sew the 1½" x 21½" purple strips to the top and bottom. Add the 1½" x 25" strips to the sides.

9. Sew the 5½" x 23½" white strips to the top and bottom. Add the 5½" x 35" strips to the sides.

10. From the ½"-wide bias strips, make four ¼"-wide bias vines, each approximately 42" long. Refer to "Making Bias Vines" on page 19. Appliqué in position, referring to the photo on page 124.

11. Appliqué the leaves and flowers in position, using the photo as a guide.

12. With six strands of embroidery floss, sew a running stitch along the pencil lines to divide your center background square into nine squares. Refer to "Embroidery Stitches" on page 21. Leave a 3" tail at the beginning and end of each stitching line. Divide the tails into two sections of three strands each, and tie a knot. Trim the thread tails to ¾".

Finishing the Quilt

Refer to "Quilting and Finishing" on page 29 for more details if needed.

1. Mark a quilting design on the quilt top if desired. See the quilting suggestion below.

2. Layer the quilt top with batting and backing; baste.

3. Quilt by hand or machine.

4. Sew buttons to the heart centers and white inner border strip.

5. Bind the edges of the quilt.

6. Add a label to the back of your quilt.